How To Keep A Sketchbook Journal

BY CLAUDIA NICE

Salal
GAULTHERIA shallon
Heath family

NORTH LIGHT BOOKS
Cincinnati, Ohio
www.nlbooks.com

Sketched at Cape Lookout, Oregon Coast. July 1985

ABOUT THE AUTHOR

Claudia Nice is a native of the Pacific Northwest and a self-taught artist who developed her realistic art style by sketching from nature. She is a multimedia artist, but prefers pens, ink and watercolor when working in the field. Claudia has been an art consultant and instructor for Koh-I-Noor Rapidograph and Grumbacher. She travels across North America conducting workshops, seminars and demonstrations at schools, clubs, shops and trade shows. Claudia has recently opened her own teaching studio, Brightwood Studio (www.brightwood studio.com), in the beautiful Cascade wilderness near Mt. Hood, Oregon. Her oils, watercolors and ink drawings have won numerous awards and can be found in private collections across the continent.

Claudia has authored fifteen successful art instruction books, including *Sketching Your Favorite Subjects in Pen & Ink*, *Creating Textures in Pen & Ink With Watercolor*, *Painting Nature in Pen & Ink With Watercolor* and *Painting Weathered Buildings in Pen, Ink & Watercolor*, all of which were featured in the North Light Book Club.

When not involved with her art career, Claudia enjoys hiking and horseback riding in the wilderness behind her home on Mt. Hood. Using her artistic eye to spot details, Claudia has developed skills as a man-tracker and is involved, along with her husband, Jim, as a search-and-rescue volunteer.

METRIC CONVERSION CHART

TO CONVERT	TO	MULTIPLY BY
Inches	Centimeters	2.54
Centimeters	Inches	0.4
Feet	Centimeters	30.5
Centimeters	Feet	0.03
Yards	Meters	0.9
Meters	Yards	1.1
Sq. Inches	Sq. Centimeters	6.45
Sq. Centimeters	Sq. Inches	0.16
Sq. Feet	Sq. Meters	0.09
Sq. Meters	Sq. Feet	10.8
Sq. Yards	Sq. Meters	0.8
Sq. Meters	Sq. Yards	1.2
Pounds	Kilograms	0.45
Kilograms	Pounds	2.2
Ounces	Grams	28.4
Grams	Ounces	0.04

This hardcover edition of **HOW TO KEEP A SKETCHBOOK JOURNAL** features a "self-jacket" that eliminates the need for a separate dust jacket. It provides sturdy protection for your book while it saves paper, trees and energy.

05 04 03 02 01 5 4 3 2 1

Library of Congress Cataloging-in-Publication Data

Nice, Claudia
 How to keep a sketchbook journal / Claudia Nice.-- 1st ed.
 p. cm.
 Includes index.
 ISBN 1-58180-044-4 (alk. paper)
 1. Drawing--Technique. 2. Notebooks. I. Title.
NC730 .N5 2001
741.2--dc21 00-045213

Editor: Amy J. Wolgemuth
Production Editor: Christine Doyle
Production Coordinator: Sara Dumford
Designer: Amber Traven

I dedicate this book to all those who are wise-hearted, who seek knowledge and truth and, upon finding it, hold it sacred.

For I believe life is not about fairness, winning or losing, but about learning—
Learning to seek out the good and appreciate it.
Learning to avoid the worldly pitfalls.
Learning to change the bad that can be bettered and enduring the painful that can not, with hope and dignity.
Learning the value of integrity, sacrifice, fulfillment and unselfish love.

—— Claudia Nice

CAPE LOOKOUT, OR
MAY 1981

Table of Contents

Smokey Mountain Farm House
8 1/2" x 11" (22cm x 28cm)
Watercolor textured with a glass dip pen, calligraphy ink and the pen blending technique
(See page 96 for the preliminary thumbnail sketches.)

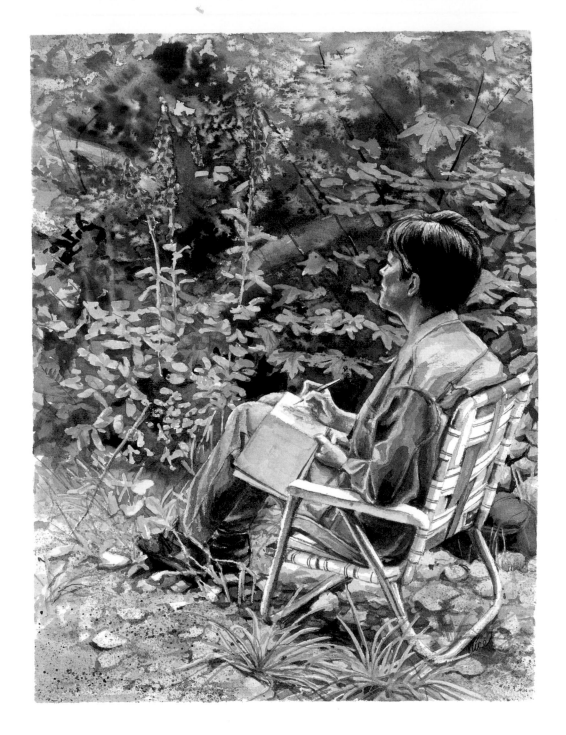

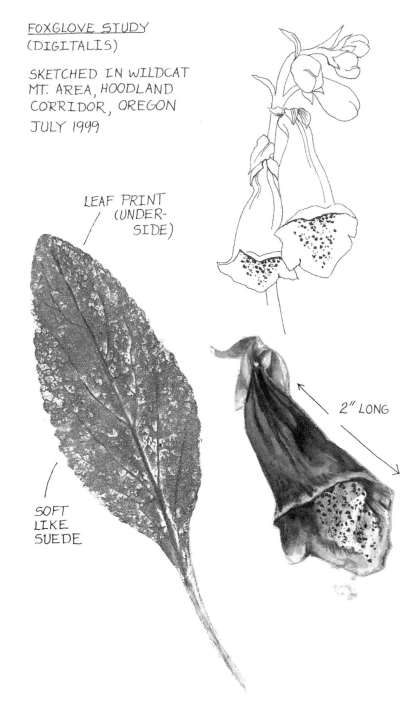

FOXGLOVE STUDY
(DIGITALIS)

SKETCHED IN WILDCAT
MT. AREA, HOODLAND
CORRIDOR, OREGON
JULY 1999

LEAF PRINT
(UNDER-
SIDE)

SOFT
LIKE
SUEDE

2" LONG

Introduction

What is a sketchbook journal? As the name suggests, it is a book, usually bound, containing both sketches and bits of personal history and observations. More than a diary of written words, it is an outlet for visual expression and artistic creativity. Where words leave off, the sketchbook journal awakens the mind with shapes, colors and textures, all seen through the eye of the recorder and preserved in his own personal style.

As a very personal work, the sketchbook journal need not be shared with everyone. It is not a minigallery open to public critique, but rather a safe haven where the creative mind is allowed to express, experiment, discover, document and dream, with no thought of pleasing others. Therefore, one should never apologize for the art or thoughts contained within. Rarely are the sketches contained in a journal the recorder's best art. The sketches are often quickly made; if they catch the essence of a memory, they have done their job. Only the illustrations in an in-depth study journal need be as detailed and precise as possible.

Within the pages of this book, I have shared many entries based on my personal memory and sketchbook journals. Some of the illustrations are detailed and elaborate, reflecting days when I had plenty of time and interest to devote to the subject; other sketches are mere scribbles. Nevertheless, each one reminds me of a specific subject or experience and is therefore adequate. The written journal entries are penned in uppercase block letters so that you can distinguish them from other text. Any idiosyncrasies or unique spellings in the journal pages add to the inherent integrity of the artwork and should be enjoyed as such. They only enhance the work and make it more personal.

It is my hope that this glimpse into the pages of my life, as well as the instruction and advice contained within this book, may inspire you to begin your own sketchbook journal. Remember that there is no greater way one can celebrate life than to create a legacy of memories.

Best wishes,

Claudia Nice

CATHIE SKETCHING FOXGLOVES
7 1/4" x 9 1/2" (18cm x 24cm)
Watercolor

Types of Sketchbook Journals

<u>The Theme Sketchbook Journal</u> explores a specific subject of special interest to the journal keeper. For example, the journal of an equestrian may include only entries and drawings pertaining to horses, while the mariner may limit his sketchbook journal to ships and seascapes.

Purpose: To obtain creative enjoyment and gain insight into an area of special interest.

(from OLD WEST Theme Journal)

IRIS BED PLANTED IN THE SPRING, 1998. FIRST BLOOM— JUNE 3, 1999

MAY WEATHER WAS VERY WET AND COOL.

<u>The Garden Keeper's Sketchbook Journal</u> is simply an old-fashioned garden diary with the refinement of illustrations added. Traditionally the garden journal has been used to keep track of weather, plantings, prunings, propagation, bloom dates, harvests, etc., by those who cultivate the soil.

Purpose: To record useful gardening information, document horticultural experiences, and to express artistically an appreciation for plants, flowers and gardening in general.

<u>Discovery Sketchbook Journals</u> accompanied such adventurers as Meriwether Lewis and William Clark into the unknown territories they explored. In these books they compiled accurate records, both written and illustrated, of the regions they traveled through, and the wildlife, native people, climate and natural resources they found there. However, you need not be an explorer to record interesting personal discoveries. The strange mushroom seen on a hike, the unidentified thing-a-ma-jig from the attic, an especially vibrant sunset and the weird looking bug on the screen door would all make intriguing entries in a discovery sketchbook journal.

Purpose: The documentation of discoveries, and to observe and gain a better understanding of the world.

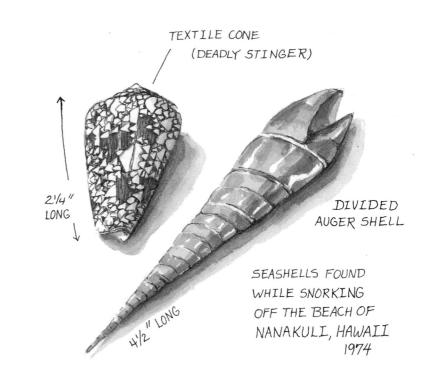

TEXTILE CONE
(DEADLY STINGER)

2¼" LONG

4½" LONG

DIVIDED AUGER SHELL

SEASHELLS FOUND WHILE SNORKING OFF THE BEACH OF NANAKULI, HAWAII 1974

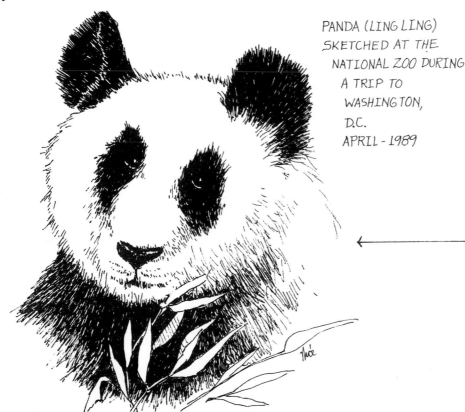

PANDA (LING LING) SKETCHED AT THE NATIONAL ZOO DURING A TRIP TO WASHINGTON, D.C. APRIL - 1989

<u>The Illustrated Travel Journal</u> is a visual record of the scenery, people, flora, fauna, culture and local color encountered while traveling. The territory may be new to the journal keeper, which makes the record double as a discovery journal. If the journal keeper is returning to old and familiar places, he may simply wish to record beloved sights to review and ponder at a later date. The travel journal may consist of one trip or a collection of many travels.

Purpose: Documentation, nostalgia and creative enjoyment.

An Illustrated Reference Journal serves as a visual storehouse of ideas and information to augment the memory of the record keeper. In such a journal the architect may set down structural concepts as he envisions them, while the birder may sketch and record the markings of his latest feathered find. The artist may use the Reference Journal as a place to make thumbnail sketches of interesting subject matter, and to experiment with shapes, values and color.

Purpose: A place to record ideas and information pertaining to ongoing or future projects.

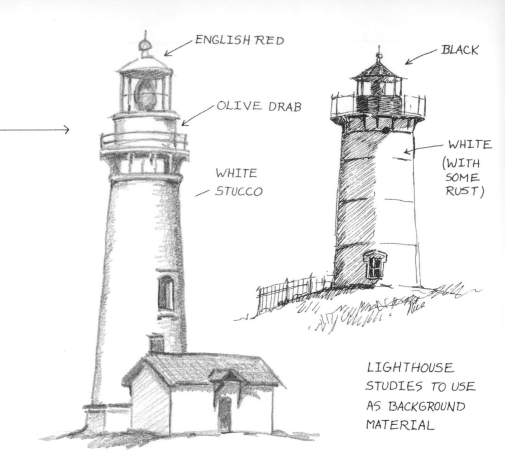

ENGLISH RED

BLACK

OLIVE DRAB

WHITE (WITH SOME RUST)

WHITE STUCCO

LIGHTHOUSE STUDIES TO USE AS BACKGROUND MATERIAL

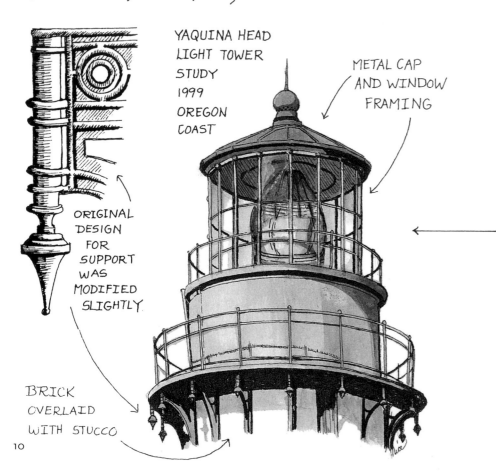

YAQUINA HEAD LIGHT TOWER STUDY 1999 OREGON COAST

METAL CAP AND WINDOW FRAMING

ORIGINAL DESIGN FOR SUPPORT WAS MODIFIED SLIGHTLY

BRICK OVERLAID WITH STUCCO

The In-Depth Study Sketchbook is a combination of a Discovery Journal and a Reference Journal, in which the subject is drawn in great detail, showing several views. The field notes are quite thorough. It may cover one category of subjects, or relate to many different things. This articulate sketchbook journal is popular with scientific illustrators, researchers, naturalists, perfectionists and the curious who require accuracy in their work.

Purpose: Precise documentation of a subject.

A Sketchbook of the Imagination is an illustrated flight of fancy in which the journal keeper records whatever his mind dreams up. Wood sprites, wee winged folk, unicorns, dragons and monsterous beasts may be found within it's pages. In such a sketchbook journal, the science fiction writer may experiment with characters, vehicles and scenery from fantasy worlds. The creator of children's stories may sketch cute and cuddly animals with human traits.

Purpose: To serve as an outlet for a creative imagination, where fantasies can be recorded and dreams can be explored.

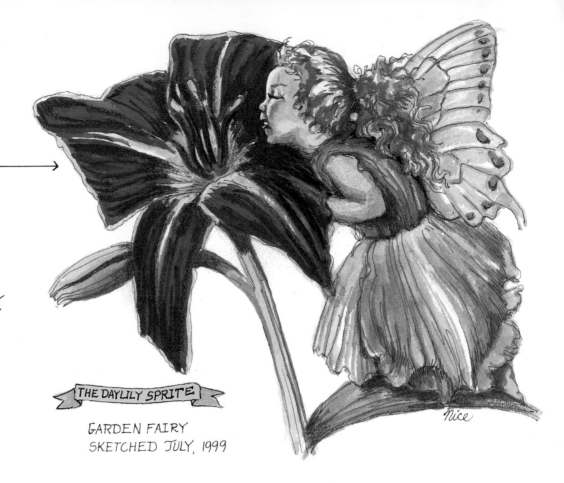

THE DAYLILY SPRITE

GARDEN FAIRY
SKETCHED JULY, 1999

FISHERMAN'S WHARF - MONTERAY BAY, CALIFORNIA
JAN. 1998 (INSTRUCTOR AT NORTH LIGHT
 WATERCOLOR WORKSHOP)

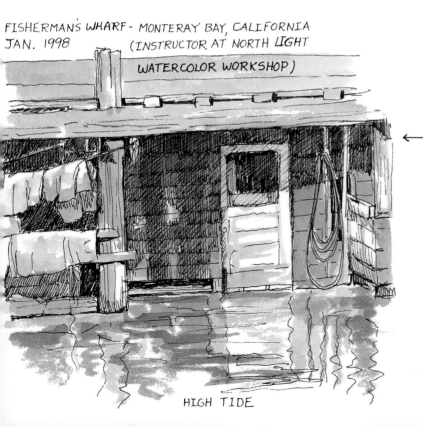

HIGH TIDE

The Life Sketchbook Journal is a visual diary, reflecting the experiences of the journal keeper over a set period of time. It may contain elements of all the other journal types, according to what is seen, felt or imagined by its creator. The Life Sketchbook Journal may also include drawings and entries set down by family, friends or mentors. There may be an autograph or two. Whatever has meaning to the journal keeper can become part of his life's record.

Purpose: To preserve memories and record one's personal history for posterity.

11

Written Entries

Pictures may be worth a thousand words, but a sketchbook journal lacking pertinent written notations is less than complete.

To help my memory, I identify what the subject is. If it's a person or place, I write down the formal name.

WATER DROPS — IT STARTED SNOWING WHILE I WAS SKETCHING.

TRAIL WAS RUGGED, RUNNING ALONG THE EDGE OF THE HIGH CLIFFS.

DEVIL'S PUNCH BOWL. EAGLE CREEK TRAIL, COLUMBIA RIVER GORGE, OR. HIKED – APRIL, 1982

MOOSE
DELTA JUNCTION
ALASKA
MARCH 1988

(I WAS TEACHING AN ART WORKSHOP AT THE MILITARY BASE.)

I also record the date the sketch was made and the location. I may add a notation of why I was there - (vacation, travel teaching, field trip or whatever).

I often make comments on the weather, terrain and interesting facts relating to the subject.

APRIL 1980 ERUPTION OF
MOUNT ST. HELENS.
(LOCATED IN THE CASCADE
MOUNTAIN RANGE,
WASHINGTON STATE)

ERUPTIONS BEGAN IN
MARCH AND ENDED IN
MAY WHEN PART OF THE
PEAK WAS VIOLENTLY
BLOWN AWAY, CREATING
GREAT ASH CLOUDS, MUD
FLOWS AND DESTRUCTION.

It is very helpful to describe
details that are not apparent
in the drawing, painting or
quick sketch. This might
include size, color, texture,
odors, sounds, mood, situations
and reactions.

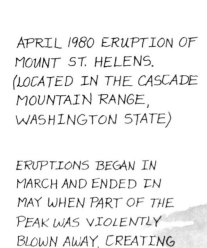

APPEARED TO BE MORE GAS AND
STEAM, THAN ASH. CLOUD WAS
WHITE AND BILLOWY.

COLUMBIA
RIVER

VIEWED FROM
OREGON BORDER

In short, supplement your illustrations with
whatever written information will be necessary
to fully understand and appreciate your entry
at a later date.

13

SIZES— NO. 2, NO. 4, NO. 8

ROUNDS WASH BRUSH

AQUARELLE 1/2 INCH FLAT OR BRIGHT 1/4 INCH

Materials

Good tools and art supplies are essential to the success of any project. The joy of creation can be greatly discouraged when the artist has to fight with her art equipment to succeed. One need not buy the most expensive tools, but a few good-quality supplies are better than a bucketful of inferior implements. One must learn the nature of art materials in order to choose wisely.

The Journal

If the journal is meant to store a lifetime of memories, then it should be strong enough to last a lifetime. Choose a journal with a sturdy binding that will withstand much handling. The paper should have a neutral pH and a surface quality that will support pencil, pen and light watercolor washes. Paper that is too soft or thin will allow pen work to fray out and will permanently buckle when washes are applied. Look for a smooth paper surface with a bit of sheen. My early journals were written in hardcover sketchbooks from Grumbacher, ranging in size from 11" x 14" (28cm x 36cm) to 5 1/2" to 8 1/2" (14cm x 22cm). For a touch of elegance, Savoir Faire makes several extra-special journal books.

For watercolorists who wish to work on a watercolor paper surface, there are several sketch pads available. Unfortunately, most either have gummed or spiral bindings that do not hold up to a lot of viewing. I suggest removing the sheets and remounting them in archival plastic sleeves, to be placed in a three-ring binder or similar cover. I also recommend acid-free, 125-lb. (267gsm) or 140-lb. (300gsm) cold-press watercolor paper by Arches, Savoir Faire (Fabriano Uno) or Winsor & Newton (Cotman Water Colour Paper).

Pencils

The humble pencil is an important tool for creating both correctable preliminary sketches and effective finished drawings. Graphite pencils are classified according to degree of hardness. Hard (H) to extremely hard (9H) make light-value marks. Soft (B) to extremely soft (8B) make dark-value marks that readily smear and blend. HB and no. 2 writing pencils, which were used for the art in this book, are of medium hardness.

There are a variety of colored pencils available, some of which are water soluble. I am most familiar with Prismacolor pencils, which have worked well for me in illustrating parts of my journals.

Pens

The ideal pen has a steady, leak-free flow and a precise nib that can be stroked in all directions. The Koh-I-Noor Rapidograph, a technical pen, meets these standards and was used to produce most of the pen-and-ink work in this book. The Rapidograph consists of a hollow nib, a self-contained, changeable ink supply and a plastic holder. Within the hollow nib is a delicate wire and weight that shifts back and forth during use, bringing the ink forward. There are numerous nib sizes, 3 x 0 (0.25mm) being the one I use most often. Drawbacks: cost and maintenance. Like any fine instrument, the Rapidograph pen requires proper care and cleaning.

A more economical and maintenance-free version of the technical pen is the disposable Artist Pen by Grumbacher. It comes prefilled with a quality, brushproof ink. Drawback: not refillable.

Dip pens are economical and consist of a plastic or wooden holder and changeable steel nibs. With Hunt

nib no. 102 (medium) or no. 104 (fine), the Crow Quill dip pen provides a good ink line. It cleans up well and is useful when a variety of colored inks are being used. Drawbacks: Crow Quill pens are limited in stroke direction and must be redipped often. They also tend to drip and spatter.

Glass dip pens are elegant in nature and fun to use. The spiral-grooved head catches and holds the ink, then channels it to the nib. The width of the nib tip determines the line width. Beautiful J. Herbin glass pens are available through Savoir Faire. Drawback: very breakable!

Sakura Pigma Micron pens are another alternative to a technical or dip pen. They provide a permanent, fine ink line. Drawback: One never knows exactly when the ink will run out. A spare pen is a good idea.

INK

For mixed-media work, choose an ink that is lightfast, compatible with the pen you are using and brushproof to withstand the overlay application of wet washes without bleeding. Permanent inks are not necessarily brushproof and must be tested. For a very brushproof black India ink, I recommend Koh-I-Noor's Universal Black India 3080. For a lightfast, brushproof colored ink, I use FW Acrylic Artist's Ink (transparent) or archival-quality colored inks by Koh-I-Noor.

Lightfast, nonpermanent calligraphy inks, such as Winsor & Newton's drawing inks, can be applied over watercolor work with a glass dip pen to add detailing and texture. The nonpermanent quality of the ink allows the pen work to be softened and blended into the watercolor painting using a moist wash. If applied to a damp surface, even the waterproof colored inks will flow and blend into the watercolor work naturally (pen blending), which is great for creating wood grain, marbling, foliage, and so on. However, the calligraphy inks are alkaline while the watercolors are acidic, and the permanency of the two mixed has yet to be proven.

WATERCOLORS

Look for a watercolor paint that has rich, intense color, even when thinned to pastel tints. It should be finely ground and well processed, with no particle residue, so washes appear clean. Colors should have high lightfast ratings. The paintings in this book were created using Grumbacher, M. Graham and Winsor & Newton watercolors.

BRUSHES

The best watercolor brushes are made of sable. Soft, absorbent sable brushes are capable of holding large amounts of fluid color while maintaining a sharp edge or point. They respond to the hand with a resilient snap. However, they are expensive. A good sable blend or a quality synthetic brush can provide an adequate substitute. Avoid brushes that become limp and shapeless when wet, or are so stiff they won't flow with the stroke of your hand. Watercolor brushes should be used only for watercolor. The sizes and shapes I use most often are shown at left.

OTHER USEFUL TOOLS

* white vinyl eraser
* art masking fluid (Winsor & Newton) to protect white paper areas when working with watercolor
* spray fixative to prevent pencil work from smearing
* old round brushes for applying masking fluid or ink washes
* Liquid Paper Correction Fluid for fixing small ink mistakes
* pencil sharpener
* facial tissues and paper towels for blotting and cleaning up
* 8" (20cm) clear plastic ruler
* small water container
* white plastic palette box

For additional information on tools and techniques, refer to two of my other books: *Sketching Your Favorite Subjects in Pen & Ink* and *Creating Textures in Pen & Ink With Watercolor*, both published by North Light Books.

GLASS DIP PENS — JUST FOR FUN!

Making A Field Kit

Several years ago I made a denim case to hold my 5½ x 8½ inch journal and all the supplies needed to work in it. It's very portable and ready to go when I am. Here's how to make one of your own. —

① Start with a 14 x 24 inch piece of denim. Sew bias tape over the edge of one of the 14 inch ends. Round off the corners of the opposite end.

② Fold up the bound edge 6½ inches and sew it down at the outer edges to form a large pocket. Slip your journal into the left hand side of the pocket and pin the pocket together along the right side of the journal, about 7½ inches wide. Remove the book and sew the pocket together. Divide and sew the right hand side into three smaller compartments to hold pens, pencils, a ruler, etc.

④ Cut two 6 x 7 inch pocket shapes from denim. Turn under the edges and sew them down to create a smooth rim. Hand sew the pockets to the back side of the case, an inch up from the folded edge.

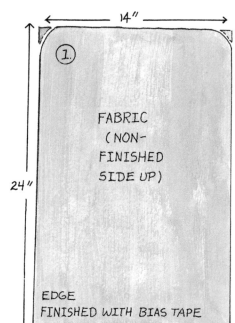

FABRIC
(NON-FINISHED
SIDE UP)

14"

24"

EDGE
FINISHED WITH BIAS TAPE

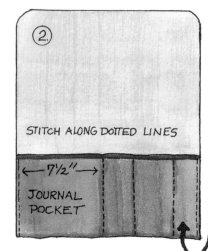

②

STITCH ALONG DOTTED LINES

←7½"→

JOURNAL POCKET

FOLD UP 6½"

③ Sew ¼ inch wide bias tape over the rough outer edge of the material. Cut a 44 inch length of bias tape and sew it closed. Fold it in half and sew it to the upper edge of the journal pocket for a tie str.. Shoe strin.. or a leath.. thong wou.. also work well.

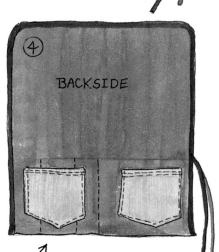

③

INSIDE FLAP

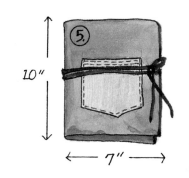

④

BACKSIDE

⑤ To close the field kit case, fold the rounded edge flap over the pocket compartment, and fold both sides inward like the cover of a book. Wrap the strings around the outside and tie closed.

⑤

10"

←7"→

(Old jeans hip pockets work well and add a country flare to the field kit.)

I carry the following supplies in my field kit, listed pocket by pocket. ~

① • A 5½ x 8½ inch bound journal
• Several folded paper towels
• A collapsible water bucket

② • An 8-inch clear plastic ruler
• A sepia sketching pencil

③ • Koh-I-Noor Rapidograph pens sizes .18, .25 and .50, or Grumbacher Artist pens
• Koh-I-Noor Universal Black India Ink (3080F)
• Synthetic brushes for ink washes - no. 4 round ¼-inch flat

④ • A mechanical pencil
• A vinyl eraser strip and holder
• A pencil sharpener

⑤ • A 2 x 4 inch child's novelty paint box, emptied and refilled with basic tube water colors.
• A small pouch of expandable watercolor field brushes, (Isabey) nos. 1 and 5 round, and a small mop brush. I also trimmed the handle of a ¼-inch flat brush and added it.

I ADDED VELCRO ALONG THE POCKET OPENING TO SECURE IT CLOSED.

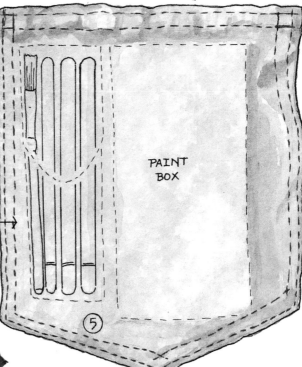

PAINT BOX

⑤

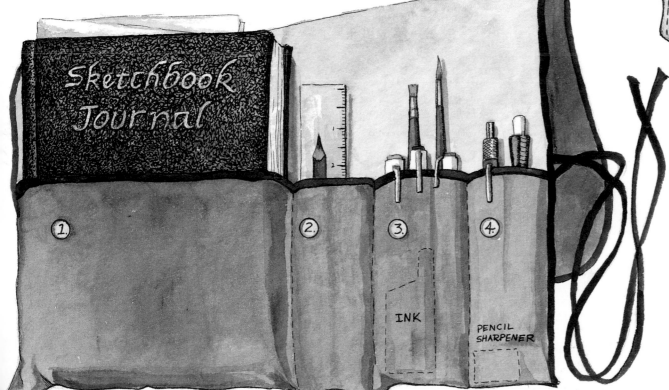

Sketchbook Journal

①

② ③ ④

INK

PENCIL SHARPENER

The second hip pocket (not shown) is for a small box of colored pencils and palette paper.

Note: If you can't find expandable field brushes, tuck regular-size watercolor brushes in one of the small inside pockets.

An old eye shadow case can be used for a miniture watercolor paint box. Use hot glue to divide or create more pans.

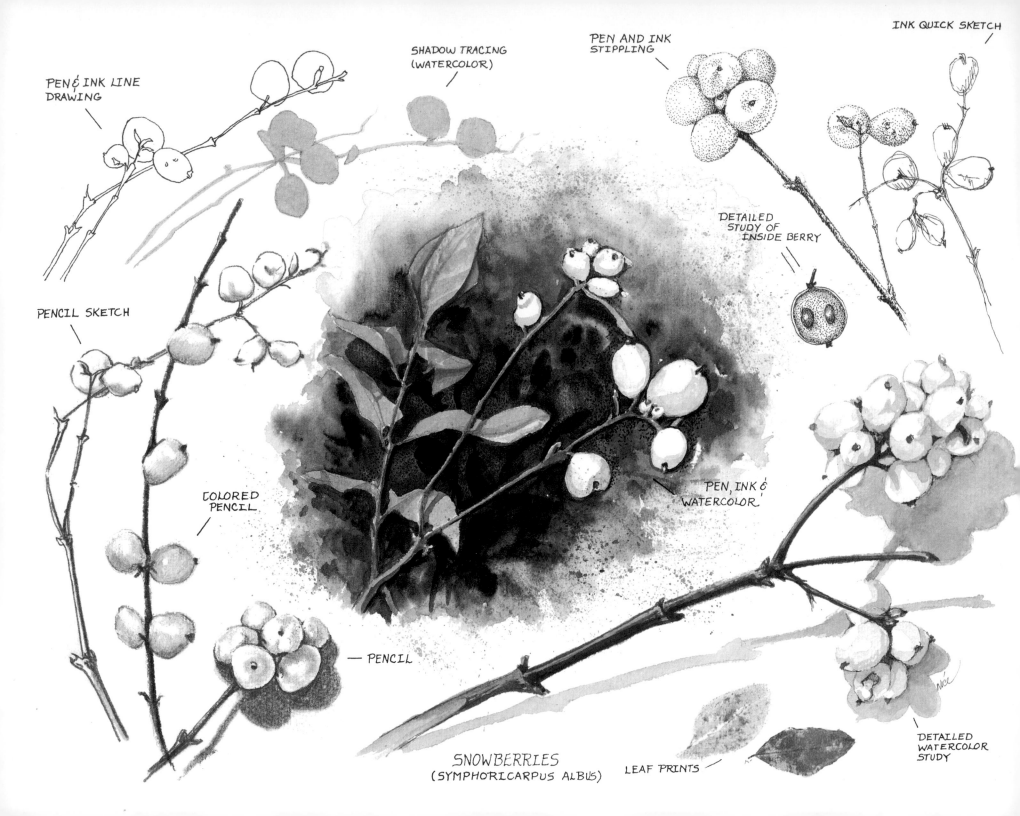

PEN & INK LINE
DRAWING

SHADOW TRACING
(WATERCOLOR)

PEN AND INK
STIPPLING

INK QUICK SKETCH

DETAILED
STUDY OF
INSIDE BERRY

PENCIL SKETCH

COLORED
PENCIL

PEN, INK &
WATERCOLOR

— PENCIL

DETAILED
WATERCOLOR
STUDY

SNOWBERRIES
(SYMPHORICARPUS ALBUS)

LEAF PRINTS

Chapter 2 — Making Sketches

While walking in the forest behind my house one overcast December morning, the snowberries caught my eye. They hung luminously on their slender stalks, like tiny holiday lights amidst an otherwise dark and gloomy landscape. I picked a few branches with berries, then headed back to the warmth of my studio to sketch them.

As you can see by the results shown on the preceding page, there is certainly more than one way to depict them. Each style and method makes its own statement about the berries, one not necessarily better than the next—just different. Mood, time, technique and purpose are reflected in each sketch, but all of them say "snowberry." Even the simple shadow tracing makes an interesting journal entry. No matter what a person's art experience or ability, there is a place to start. I believe the ability to draw is learned, like handwriting. The more you practice, the more skillful and observant you become, and the easier it is to depict the images you see. No one is born with artistic ability, only an innate desire for creative expression. The skills themselves will develop if you are inquisitive and patient enough to stick with it. However, there are some basic principles that will help awaken the artistic eye a little faster and make the learning process a little easier. I have included many in this chapter. Study them, then find a comfortable starting point and begin.

Observation

Developing the ability to notice and remember the defining qualities of an object is the first step in being able to draw it.

← Two baskets

Begin by doing away with preconceived mental images of how an object should look. Study each subject as if it were a new discovery. Search out these five qualities—

- Shape – What is its basic form?
- Value – How light or dark is it?
- Color – What hue is it? Is the color intense, pastel or muted?
- Texture – What is the tactile quality of its surface: smooth, rough, hairy, etc.?
- Border definitions – Are its edges hard and well defined, soft or obscure?

Drawings by Kaela, age 6

(Drawn from memory.)

Young children rely on learned formulas when drawing, spending little or no time looking at the actual subject. These formulas tend to stay with us, obscuring the observation process.

Basic shape

sides curve outward near the top.

Ellipse

Rectangular box

Value study

light source

These are the qualities I saw as I studied this old woven basket.

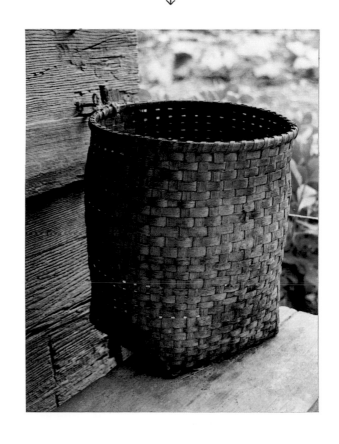

The edges are hard and well defined.

Texture is semi-rough and bumpy. The woven material has a wood grain pattern.

Color —

Orange-brown range }

Pale base color mixtures

Dark shadow mixtures

(Orange with increasing amounts of blue added.)

21

Drawing Shapes

Drawing shapes is easier than drawing objects. Simple geometric shapes like circles, ellipses, squares, rectangles and triangles are the easiest to recognize and draw. I look for these simple shapes within the more complicated structure of the object I'm drawing. I then combine them, like building blocks, to help me see and define the complete shape of the object.

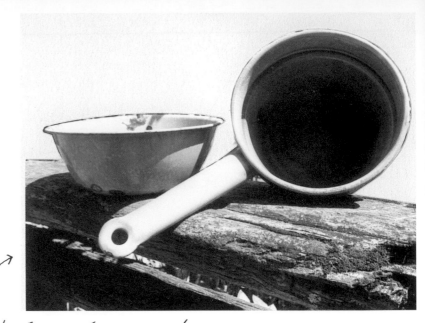

What shapes do you see in this photograph?

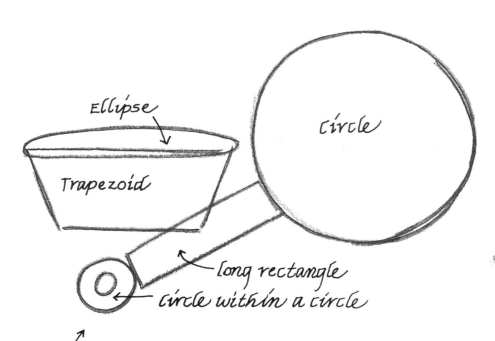

Ellipse

Trapezoid

circle

long rectangle

circle within a circle

① The overall shape of the bowl and pan broken down into simple, geometric shapes that are easier to comprehend and draw.

② The completed sketch with the six simple shapes refined into the contours of the bowl and pan. Value changes help suggest the objects' depth and dimension.

Each of the drawings on this page began as simple, overlapping geometric shapes, corresponding to the shapes seen within the subject.

Bird bodies are egg shaped. The wide end of the egg forms the breast.

Geometric shapes can be used to represent bone structures and muscle masses.

Rib cage

Scapula

Humerus

muscles round out the bone structures.

Radius

Circles form a framework in which to draw daisy petals.

Shade work often corresponds to the basic shapes first set down and the muscle masses they represent. Note how the scapula oval forms the shoulder.

Not all the petals are the same length. Variety adds interest and life to a sketch.

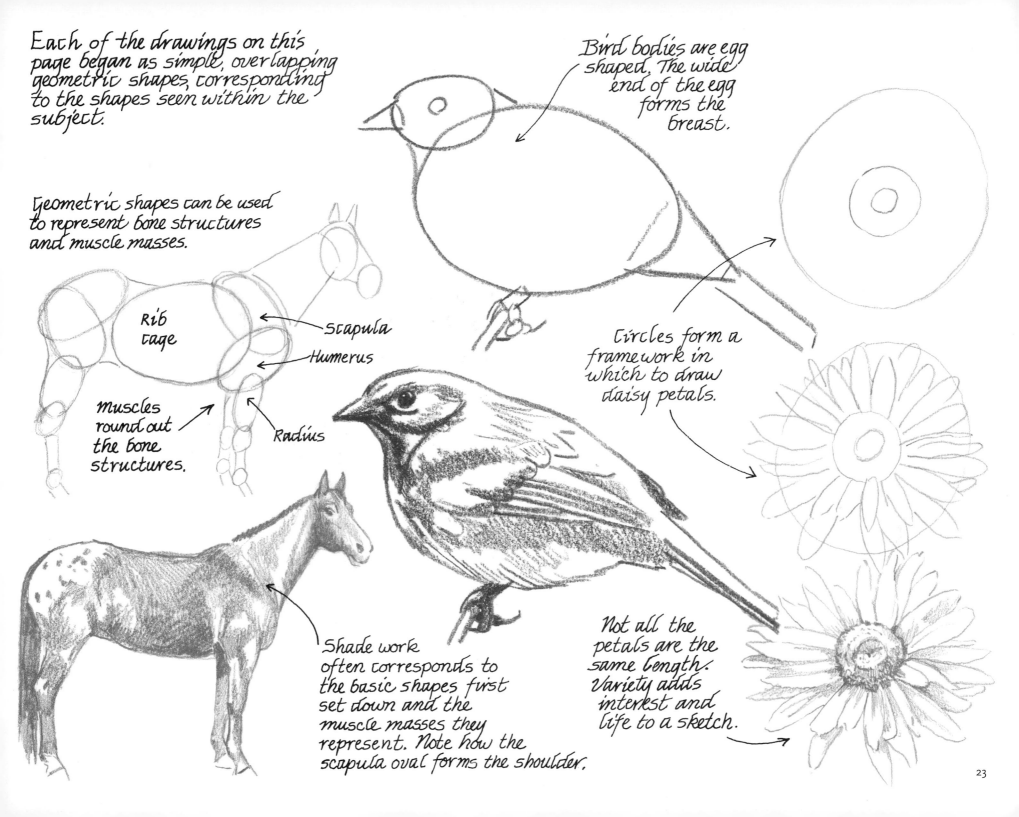

Drawing Step by Step

① Study the subject. Look for its defining qualities. Search out the smaller geometric shapes within the greater form, both positive and negative.

Make corrections and erase unneeded lines.

Negative shapes are areas surrounding the subject.

② Set down basic shapes.

③ Refine shapes into one body.

④. Add details.

The subject

Note: If lighting is unstable or sketching time is greater than 15 minutes, mark shadows in step 3.

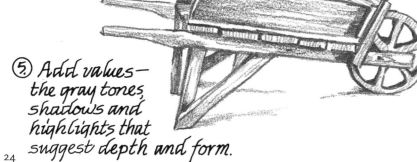

⑤ Add values— the gray tones, shadows and highlights that suggest depth and form.

⑥ Add texture and finishing touches such as soft, blended shadows and shadework.

24

Drawing Circles, Curves and Ellipses

The easiest way to draw a circle is to trace around a round object. However an appropriate sized round object may be hard to locate in the field.

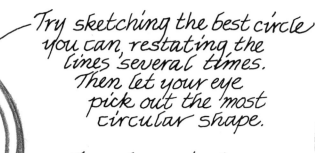

Try sketching the best circle you can, restating the lines several times. Then let your eye pick out the most circular shape.

To make a circle drawing guide, lay down lines of equal length, running outward from a center point. Then draw a curved line from section to section. The curve must remain consistent as it circles the spokes.

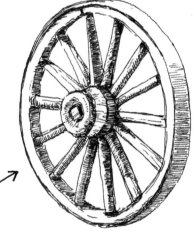

Circular shapes viewed at an angle become ellipses. The greater the viewing angle, the narrower the ellipse appears.

The narrow ends of an ellipse are always curved, not pointed.

To check the curves of an ellipse sketched freehand, surround it with a rectangle of the proper proportions. Divide the rectangle into forths and from corner to corner. The curves in the opposite corners should be mirror images of each other.

The ellipse should touch all four edges of the rectangle.

Keep in mind that freehand sketches need not be perfect, just close enough to be believable.

Objects that need to be symmetrical can be checked to see if both sides match by drawing a line down the middle. Measure outward from the middle to the edge of the object. The measurements on both sides should be equal.

25

Perspective

Perspective is the technique of depicting dimensional objects on a flat surface.

① The artist's horizon line is located at eye level. The viewer will look up to subjects above eye level (A) and down upon those below it (C). Eye level subjects are viewed straight on (B). There's only one horizon line per drawing.

② Objects appear to grow smaller as they recede into the distance, disappearing altogether at the "vanishing point." There may be more than one vanishing point in a composition, each one located somewhere along the horizon line.

Oblique vanishing point

⑤ A set of parallel, diagonal lines, like the sides of a gabled roof (D & E), are not on a horizontal plane. Therefore their vanishing point is not located along the horizon line. Such vanishing points are called "oblique."

Vanishing point

Horizon line (eye level)

③ Lines that run parallel to each other, like the roof line, foundation and horizontal window edges, will appear to grow closer together, and if extended, will converge on the horizon at a single vanishing point. Each side of a cube or building will have its own vanishing point.

If the parallel lines, shown in perspective, do not converge at the appropriate vanishing point, the building (cube) is out of perspective. This rule is very helpful in finding and correcting mistakes in freehand structure drawings.

To find the "oblique vanishing point" corresponding to the pitch of the roof, run a line upward along the near edge of the gable (D). Next locate the vanishing point for the gabled side of the building and extend it vertically. Where the two lines cross is the oblique vanishing point. Use it as a pivot point to plot the back gable's angle (E).

④ Diagonal lines drawn to the corners can be used to determine the center of a rectangle seen in perspective. A vertical line through the center will provide an accurate ridge for the roof of a building. The pitch of the roof depends on how high the center ridge line is extended.

Perspective applies to all three-dimensional subjects. The figures and shapes sketched below were drawn in perspective, using vanishing points and extended lines. They appear to recede into the distance.

Once you become comfortable with the principles of perspective, you will find that it becomes part of your drawing skills without the need to plot out vanishing points physically.

The question of how tall to make a figure relative to its placement in the foreground can be solved using a vanishing point and extended lines (G), as can the problem of getting all four feet of an animal planted firmly and squarely on the ground (H).

To establish an evenly spaced fence line, begin by drawing the first post in the foreground (I). Pick a vanishing point and run three lines to it from the top, middle and bottom of the post. Draw in a second post using the guide lines to determine its height. Running a diagonal line from the top of the first post and through the middle of the second post will show you post three's spot.

Horizon line

G

I

H

F

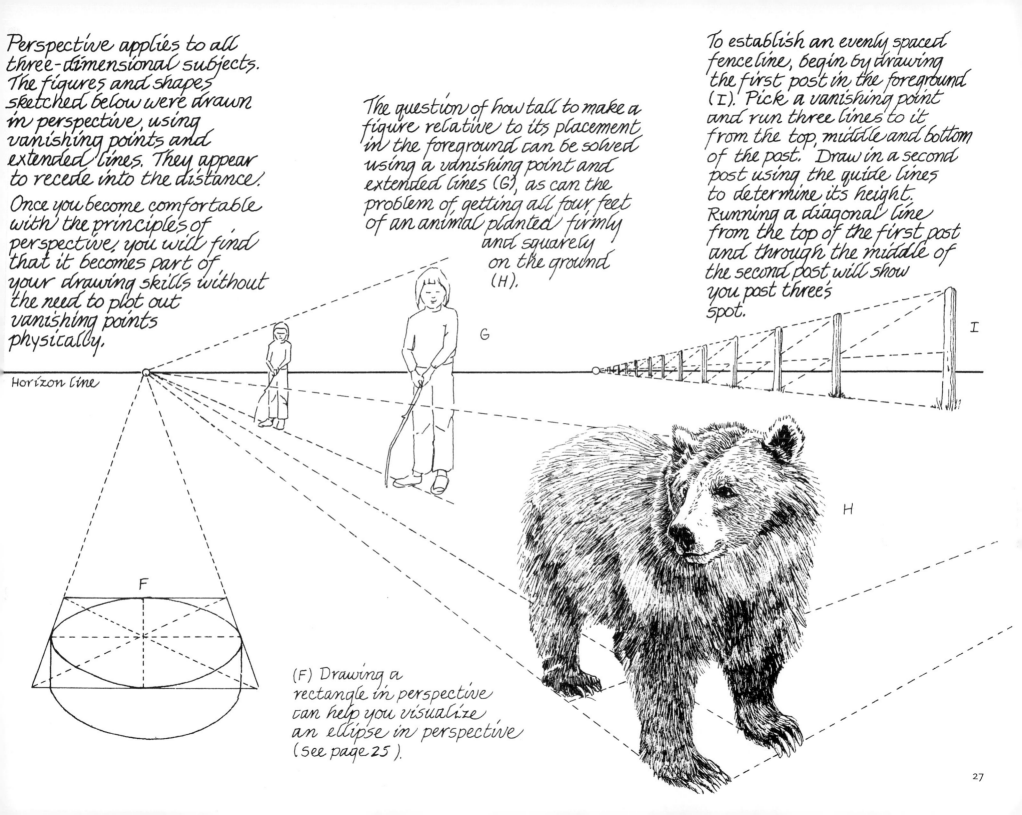

(F) Drawing a rectangle in perspective can help you visualize an ellipse in perspective (see page 25).

Using a Straight Edge

Straight edges can make excellent reference points, enabling the artist to see curves, angles, comparitive sizes and the proper placement and alignment of shapes more clearly. I prefer to use a transparent plastic ruler as my straight edge, but the side of a pencil, pen or popsicle stick will do.

To use a straight edge (ruler) as a drawing tool, follow steps one through four. (The photo of the Canada geese will serve as our subject.)

① Close one eye and, holding the ruler horizontally, sight in the mid point of the subject along the edge of the ruler (A). See which parts of the subject (goose) are above this line and which are below. This information will help you place the subject correctly on the paper.

② Now make some alignment comparisons. Shift the ruler up or down and line up horizontally on another significant part of the subject, in this case the tip of the tail (B). Note how line B also runs through the middle of the bill. You will want to make sure these two points correspond when you draw them.

③ Make as many horizontal alignment comparisons as you find useful. If the subject is alive and moving, this must be accomplished very quickly!

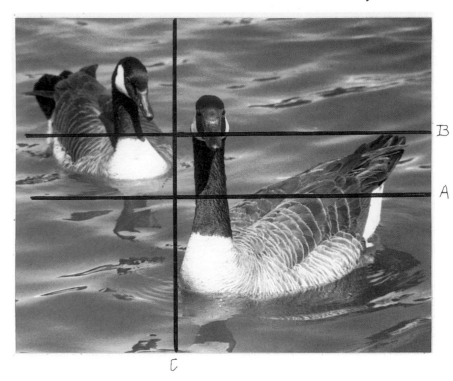

The subject

④ Turn your ruler in a vertical direction and redo the sighting in and comparative alignment process. Study line (C) and note how the position of the two birds relates to it.

— A fairly accurate quick sketch made after sighting in the subject with a ruler.

28

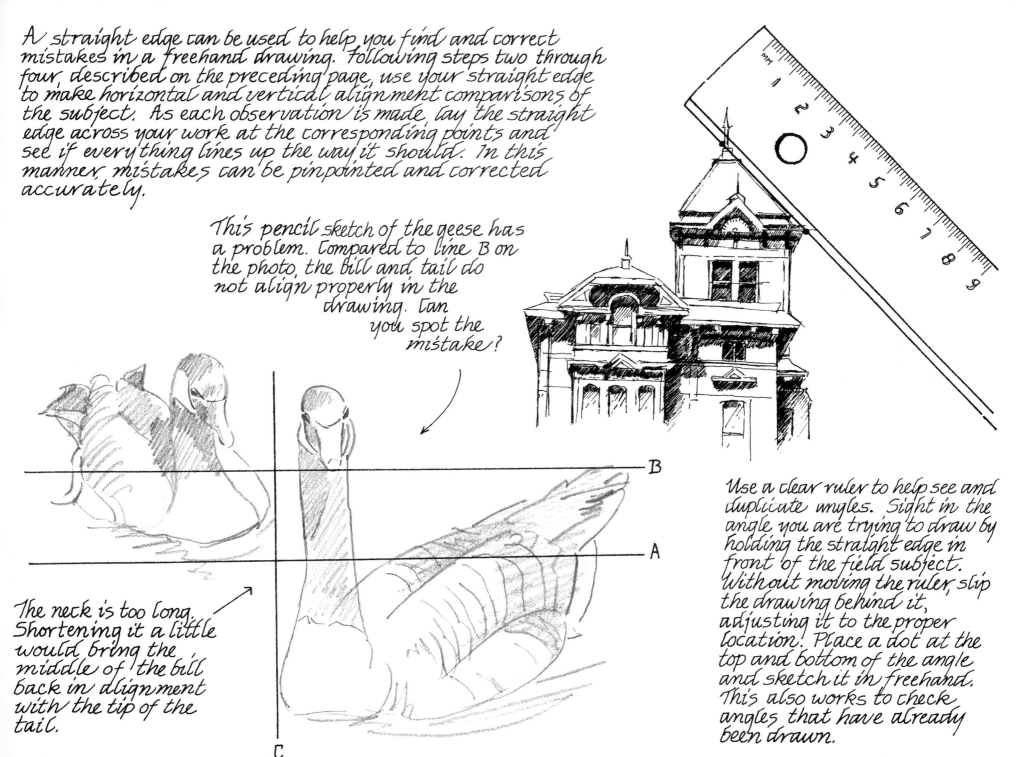

A straight edge can be used to help you find and correct mistakes in a freehand drawing. Following steps two through four, described on the preceding page, use your straight edge to make horizontal and vertical alignment comparisons of the subject. As each observation is made, lay the straight edge across your work at the corresponding points and see if everything lines up the way it should. In this manner, mistakes can be pinpointed and corrected accurately.

This pencil sketch of the geese has a problem. Compared to line B on the photo, the bill and tail do not align properly in the drawing. Can you spot the mistake?

B

A

The neck is too long. Shortening it a little would bring the middle of the bill back in alignment with the tip of the tail.

C

Use a clear ruler to help see and duplicate angles. Sight in the angle you are trying to draw by holding the straight edge in front of the field subject. Without moving the ruler, slip the drawing behind it, adjusting it to the proper location. Place a dot at the top and bottom of the angle and sketch it in freehand. This also works to check angles that have already been drawn.

29

Creating Edges

Edges can be defined using outlines, but the results are often contrived and colorbookish!

Using value contrasts, light against dark or vice versa, produces a natural looking edge. The greater the contrast, the more pronounced the edge becomes.

To a lesser degree, texture and color can also be used to create an edge.

Outlined Edge

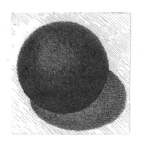

Textural Contrast

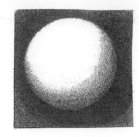

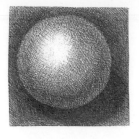

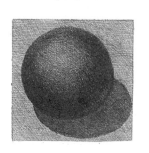

Strong value contrast

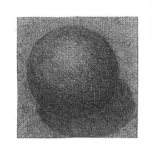

Medium value contrast

Slight value contrast

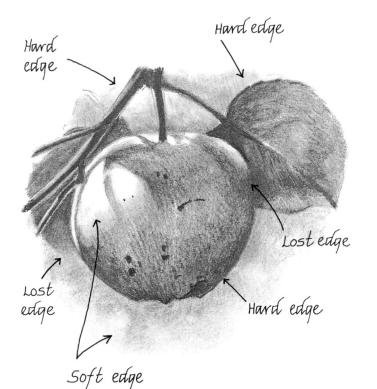

Hard edge

Hard edge

Hard edge

Lost edge

Lost edge

Lost edge

Hard edge

Soft edge

<u>Hard edges</u>, which are crisp and clearly defined, suggest —
- The perimeters of firm objects
- Folded surfaces where the direction changes abruptly
- Cast shadows created by strong light
- Soft, fuzzy or vaporous edges seen at a great distance

<u>Soft edges</u>, which are faded, fuzzy, foggy or blended in appearance, suggest —
- Curved, rounded surfaces
- Gradual folds or changes in surface direction
- Water spray, hair, wool, clouds, cotton poufs, etc.
- Cast shadows produced by poor light

<u>Lost edges</u> have perimeters that are not defined. They occur when two surfaces of the same value, texture and color run together. Lost edges can be used to —
- Minimize details
- Emphasize focus areas
- Create intriguing areas of mystery

Caution: Lost edges can also cause confusion!

30

Considering Light and Shadow

Depicting the value changes that occur when light strikes an object will give a flatly drawn shape the illusion of being a three-dimensional form. The elements of light and shadow are as follows—

Highlight: A point of intense light reflected off the surface of a form. Highlights are direct reflections of the light source and are most prominent on smooth, high-gloss surfaces.

Half-lights: Mid-tone values occuring on those portions of an object that receive partial direct light.

Form shadows: Darker-value areas occuring on those portions of an object not receiving direct light.

Note: On smooth, curved surfaces the value range from light to darkest shadow is a graduated blend.

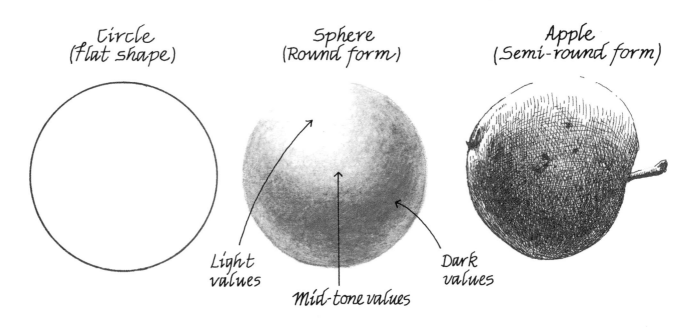

Circle (flat shape)

Sphere (Round form)

Apple (Semi-round form)

Light values

Mid-tone values

Dark values

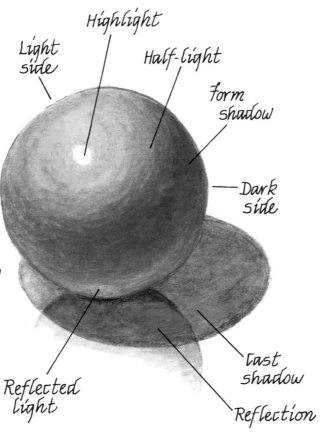

Light side

Highlight

Half-light

form shadow

Dark side

Reflected light

Cast shadow

Reflection

Reflected light: An area of lighter value cast on the dark side of an object as a result of light bouncing off another surface. Reflected light is never as intense as direct light.

Reflection: A reverse image created when light bounces off an object, then off a smooth glossy surface and back toward the viewer.

Cast shadows: An area of darker value created when an object blocks the direct light from falling onto another surface. Cast shadows reveal the contour of the surface they rest upon, but do not provide an accurate image of the objects that cast them.

31

Drawing Cast Shadows

Cast shadows are an important factor in placing an object into the scene. They reveal where the subject touches the ground or if it is raised above the ground surface. Notice in the horse drawings to the right that when the mare's nose touches the ground, the nose and nose shadow meet.

The outside perimeter of an object, as viewed in perspective, determines the edges of the cast shadow. The portions of the object hidden from view must also be considered. Drawing through the object will help you find those hidden edges.

Cast shadow on flat surface.

Rough terrain causes broken, distorted shadows.

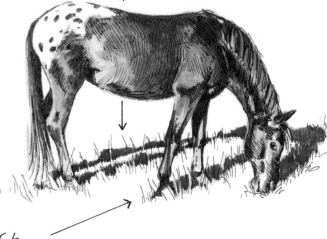

Sunlight

The sun is always moving, causing cast shadows to shift direction and vary in length. The great distance of the sun causes shadows cast at a set time of day to run parallel to each other, unless altered by the terrain.

Artificial light

The closeness of artificial light - (electric lamps, lanterns, candles, etc.) causes cast shadows to radiate outward.

These are sun cast shadows

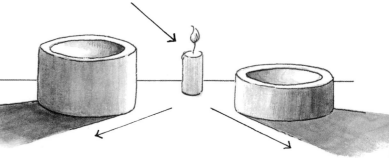

32

The very best way to create cast shadows is to draw them from life. However, light, especially sunlight, is unreliable, and still lifes often have more than one light source, making them confusing. The following principles will assist you in creating believable cast shadows.

o The light direction determines the shadow direction. They coincide.

o The height of the light source determines the light angle and the length of the shadows.

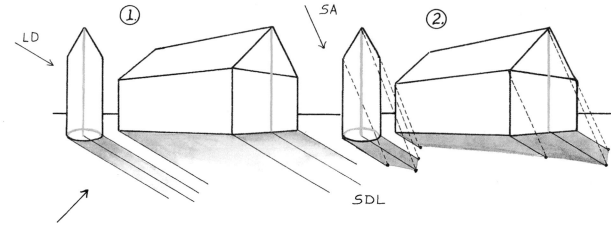

Plotting Sunlit Shadows

①— Choose the light direction (LD). Run shadow direction lines (SDL), which are parallel to the light direction and each other. These lines will correspond to the outer edges of the object, located at ground level.

②— Choose the sun angle (SA). The higher the sun, the steeper the angle and the shorter the shadow. Run lines parallel to the sun angle and each other, past the upper edges of the object, to the corresponding shadow direction lines below. Where the two lines intersect marks the end points of the shadow. All objects in the same sunlit composition will have the same shadow direction and sun angle.

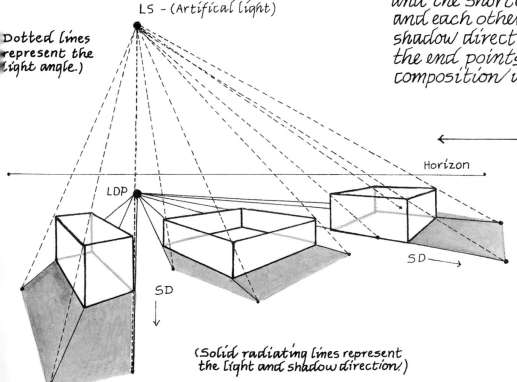

LS - (Artificial light)

Dotted lines represent the light angle.

LDP

Horizon

SD

SD

SD

(Solid radiating lines represent the light and shadow direction.)

Plotting Artifically Lit Shadows

Choose the placement of your light source (LS), and the light direction point (LDP), located directly below it on the ground plane. You may shift the light direction point up or down to place it in a foreground or background position. Run radiating lines from the light direction point past the ground level, outer edges of the objects to reveal the shadow direction (SD). Run radiating lines from the light source past the upper edges of the objects. Where they intersect the shadow direction lines, marks the end points of the shadow.

33

Miscellaneous Information

The sky gets progressively lighter in value as it approaches the horizon.

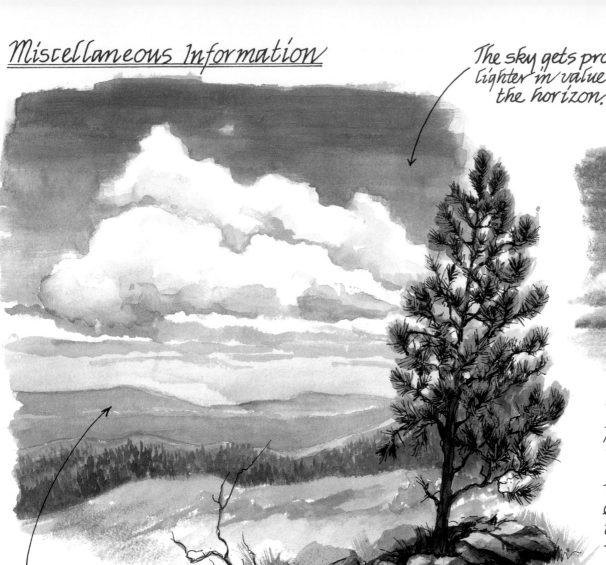

The tops of most cumulus clouds are fluffy and irregular, while the bottoms tend to be more flattened.

Use color to help set the temperature. Warm, earthy browns add heat to the rocks on the left, while the blue grays used on the rocks below place them in a cold location.

Background hills fade and take on a blue cast as they recede into the distance. This is because of the atmospheric haze between distant objects and the viewer.

Simple parallel ink lines work well to suggest distant trees.

Yellow colored pencil was used to brighten and warm the pine foliage above.

Abrupt value changes suggest fractured planes on the surface.

Water reflections are located directly below the subject that cast them and are inverted. Note how the tail, beak and breast of the gull matches up with its reflection.

Round transparent objects, like clear marbles, water drops and eyes, catch and reflect the light in a similar manner. Where the light first strikes the transparent orb, a highlight dot is reflected. (Artifical light may vary in the shape and number of highlights) The light enters the orb at the location of the highlight dot or dots, passes through and, spreads out causing illumination. This is represented by a crescent of lighter value.

sunlight

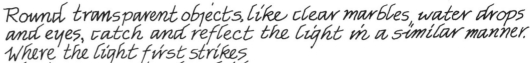

For a basic flesh tone, mix Quinacridone Rose with Burnt Sienna and mute with green.

Reflection colors are muted by the local color of the water and light reflected from the sky.

Choppy water will cause the reflection to break into distorted segments. Bits of sky reflection are often alternated in between.

Highlights (From two artifical lights)

Illumination crescent (opposite highlights)

Marble (Watercolor)

Water drop (Colored pencil)

Reflected Light

A few water surface lines across the reflection suggests that it is indeed a body of water.

35

Types of Drawings

The following sketches and drawings of my white shepherd, Dakota Snow, illustrate that there is more than one way to draw a subject. I used an action photo as the model.

Contour Drawing

This is a rough line drawing in which the pencil or pen remains on the paper, the eyes remain on the subject and the artist tries not to peek at the results until the drawing is finished. Contour drawings are great for getting a basic feel of a subject's form.

A fun exercise.

Gesture Sketch

This is a very rapid quick sketch, completed in seconds, in which basic shapes and direction of movement are merely suggested.

Quick Sketch

This is a rapidly rendered sketch in which geometric shapes are used as "building blocks" and lines are restated rather than being erased and corrected. It is meant to merely catch the essence of the subject, but some details and shade work may be included. Quick sketches are useful when time is a factor or the subject is on the move, and therefore very popular with the sketchbook artist.

Line Drawing

Line drawings are mainly concerned with the contours of the subject, which are indicated with an outline. No texture is shown, but some details and value changes may be suggested by outlining them. Line drawings may be rather refined and often begin with preliminary pencil work.

Gesture sketches, although most often incomplete, can have a wonderful sense of movement.

Thumbnail Sketches

These are miniature study sketches in which the artist experiments with various value and compositional arrangements before undertaking a more elaborate drawing or painting.

This subject arrangement seems to cut the scene in half. ——

I like the value range in this one.

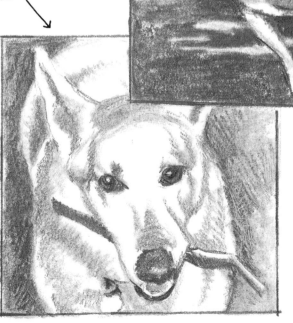

Detailed Drawing

This is a refined, finished work in which the five basic elements are represented — form, value, texture, edge definition and color (gray range if pen or pencil is being used).

Criss cross ink lines (.18 nib)

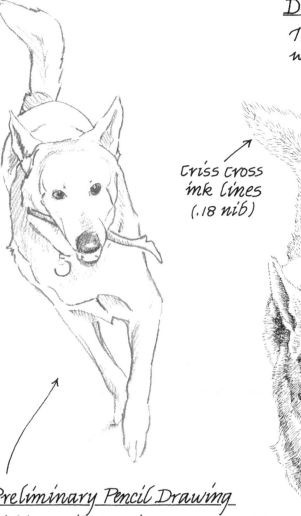

Preliminary Pencil Drawing

Light pencil drawings are often the forerunner of a more detailed work. As the preliminary drawing progresses, the form is corrected and refined, shadows are indicated, areas of value change may be marked and details are outlined. Most finished detail drawings seen in sketchbook journals are completed right over the preliminary drawing.

nice

Selecting the Subject

You're on location, pencil, pen and brush in hand. Surrounding you is 360 degrees of great subject matter and you're too overwhelmed to start. Relax! Take a few minutes to absorb the sights. Snap a few photos. Now look about you again with an artist's eye, keeping in mind your allotted time table. What interests you the most? What shape, texture or color is begging to be captured? That's where you should begin.

(POISONOUS)

FLY
AGARIC MUSHROOM
KENAI, ALASKA

I was teaching a field sketching class on the Kenai River, Alaska. The salmon were running, the fishermen were plentiful and the gulls soared overhead. What did I choose to sketch after class? — The brilliant orange mushrooms growing on the bank. They were uncomplicated and fun-just what I needed to relax after a busy day. When I look at them I am reminded of all the other scenes as well.

I've related the stories behind the sketches on this page to help explain how I choose a subject.....

Our palomino, Sundance, was grazing on the front lawn. I stood beside my large crescent shaped flower bed, admiring the blossoms. A sudden gust of evening breeze set the flowers in motion and Sundance, feeling frisky, took off at a gallop. He circled, then headed right for the middle of the flower bed. Just before he plowed through it, I yelled. Sundance gathered himself and soared right over the blossoms, his white mane flying and his body bathed in golden light. My mind was still filled with the beauty of it as I later quick-sketched it into my journal... An emotionally inspired work.

CORBETT, OR
LATE JULY 1991
SUNDANCE -
JUMPING THE
PERENNIAL
FLOWER BED.

After you have selected the subject, give it your complete focus. Include only that which is necessary to depict the subject and its immediate surroundings. Hint at its environment but don't let it take over the drawing. Be selective! Keep it simple. Keep it fun.

Simple water-color harbor sketch. ——→

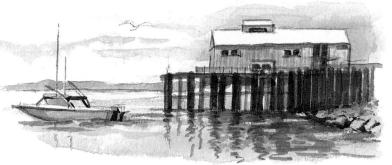

Lots of good subject matter here.

A section of railing and a bit of weathered rope was all that was needed to place this pelican in a harbor environment.

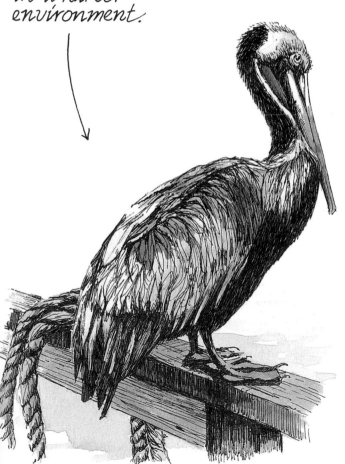

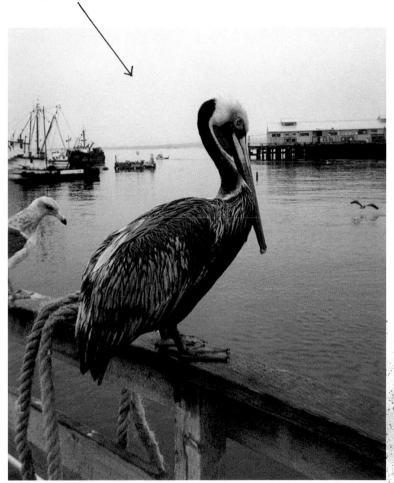

If you have decided to draw scenery, zero in on a small section of the terrain. Avoid the temptation to include everything in your field of vision. Detail in a few representative rocks, trees, shrubs, etc. to form a center of interest and merely suggest the rest with value contrast, color and simplified texture.

A rocky shore depicted simply with sponge prints and spatter. Few rocks are detailed. ——→

39

Working in the field

Sketching outdoors, on location, should be fun, safe and comfortable. Here are some field trip guide lines that have worked well for me.

The Time Factor

Decide how much time you can spend in the field. Consider your time schedule, those of your companions, your interest span, the weather, your degree of comfort, etc. Choose a subject, medium and drawing style that will allow you to complete your project comfortably in your allotted working time. Take along a camera for back up photos and to record all that great subject matter that you don't have time to sketch.

Lighting

Strong value contrasts, eye catching color and alluring shadows are the result of good light conditions. Be mindful of these natural light situations. —

. The most striking value contrasts and shadows are produced when the sun is low in the sky ... early morning or late afternoon.

. The bright noon sun tends to wash out color and obscure shadows beneath the objects casting them.

. Overcast days subdue colors and provide little value contrast. Subjects appear flat.

. Natural light is fleeting. Mark shadows quickly. Mix up some color samples to fall back on if the gorgeous hues disappear suddenly, as the sun moves behind a cloud.

Take along a companion, even if it's just the dog. Not only is it more fun to share an outdoor experience, but it's safer too!

← Student sketching up Rebel Creek canyon. Mt. Hood, Oregon

Weather – Plan for it!

In rain or wind you will need some kind of shelter – a car, cabin porch, picnic shelter, tent, etc. Pen, ink and watercolor behave badly when spattered with rain drops.

On the other hand, sunlight on white paper can be blinding. Seek the shade.

Supplies

Keep your field sketch kit simple and portable so you are not over burdened by heavy, awkward equipment to carry. Getting to the sketching location should be a pleasant experience, allowing you some freedom to enjoy your surroundings (see the field sketch kit described in chapter one).

Personal gear

If you're going to sketch away from the comfort and convenience of home, consider bringing these items—

• Clothing appropriate to climate, terrain and weather changes. A water proof cushion or bag to sit on.

• Your glasses, both prescription lenses and sunglasses.

• A brimmed hat, sun screen, insect repellent and facial tissues.

• A first aid kit and personal medications (bee sting kit, insulin, etc.)

• Drinking water and energy snacks.

• A cell phone.

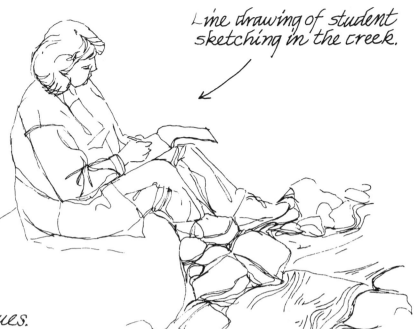

Line drawing of student sketching in the creek.

For your safety let someone know where you are going and when you are planning to return.

Stay mindful of your physical state. An artist in full concentration may not realize that he is getting too cold, too hot, hungry, thirsty or uncomfortable. Heat stroke and hypothermia are a real and deadly danger.

Last, but not least, make sure you are welcome to return. Leave the sketching site as good or better than you found it!

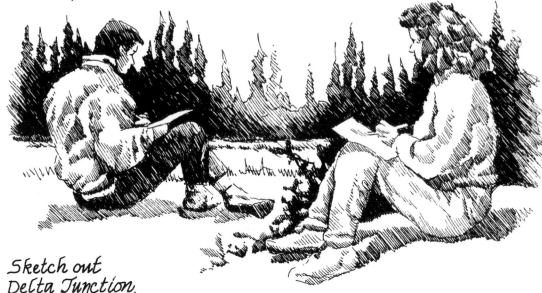

Sketch out
Delta Junction,
Alaska

Help With Human Faces

When drawing a portrait, I begin with a basic egg shape for the head. A line running from the chin to the crown of the head (A), helps me align facial features.

The eyes are located halfway between the crown and chin. An eye line (B) encircling the head will help me keep the eyes even. Eyebrow marks are placed approximately an eye's width above the eye line, in the appropriate location. Eyebrow marks are important in placing the nose and ears.

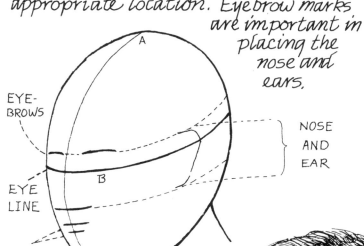

EYE-BROWS

EYE LINE

MOUTH LINES

NOSE AND EAR

keep in mind that these standard measurements can vary somewhat from face to face.

Teeth are just suggested, never outlined completely.

The bottom of the nose is positioned halfway between the eyebrows and the chin. The mouth is one-third the distance from the nose to the chin. The ears line up with the eyebrows and the nose.

In a side view, the neck is seen at an angle, tilted slightly away from the face.

It is interesting to see how the nose and ears line up, taking the middle third of the face.

42

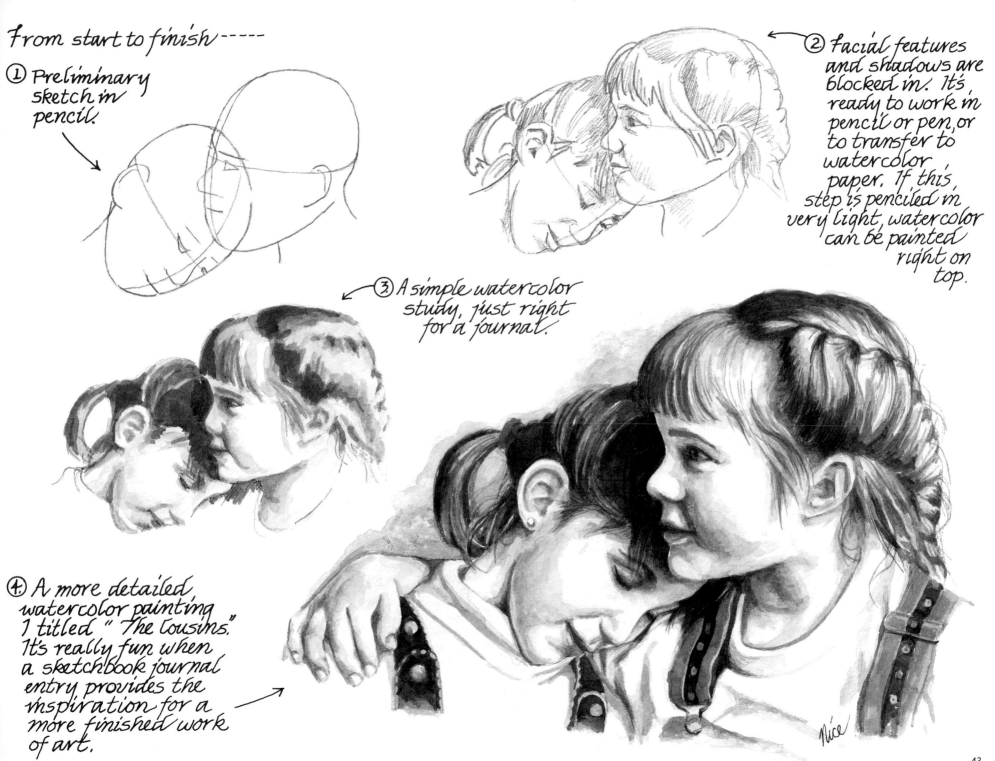

From start to finish -----

① Preliminary sketch in pencil.

② Facial features and shadows are blocked in. It's ready to work in pencil or pen, or to transfer to watercolor paper. If this step is penciled in very light, watercolor can be painted right on top.

③ A simple watercolor study, just right for a journal.

④ A more detailed watercolor painting I titled " The Cousins." It's really fun when a sketchbook journal entry provides the inspiration for a more finished work of art.

Nice

43

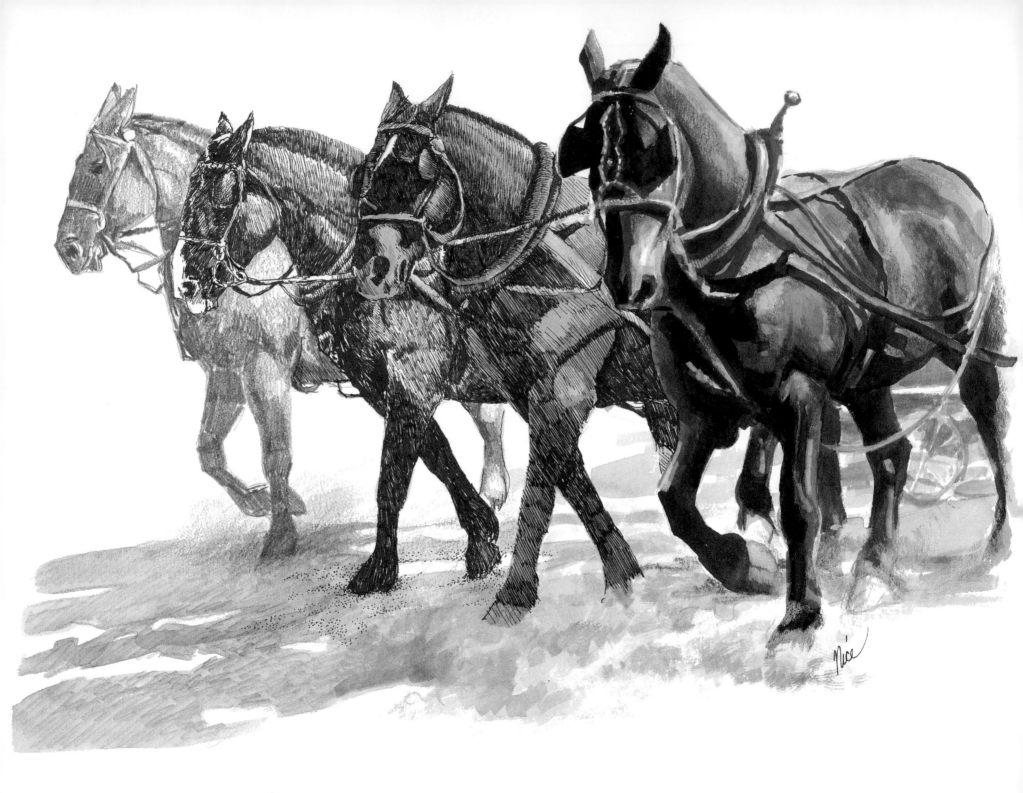

Chapter 3 — Working in Pencil, Pen & Paint

In my sketchbooks there are entries drawn in pencil, pen and colored pencil, while others are painted with ink washes or watercolor. I really don't have a preferred medium. What I choose to use depends on my timetable, mood, sketching conditions and in what detail I wish to portray the subject. If I wish to capture a semblance of the subject in a short amount of time, I usually work directly in pen and ink. Since erasing is not an option, quick ink studies have taught me to proceed boldly and not worry so much about perfection. Spontaneous ink drawings often have a vitality that outweighs the mistakes.

When accuracy is important and time is not a factor, I begin my work with a light no. 2 pencil sketch. If the subject has a lot of subtle value changes or I am experimenting with shapes and arrangements in thumbnail drawings, there is a good chance I will complete the work in pencil. If it's texture, bold value contrasts or delicate details that catch my eye, I use pen and ink to develop, refine and finish the drawing.

Some subjects demand color. Consider the brilliant hues of an autumn maple or a morning mist aglow in pastel peach. Neither subject would have the same eye-catching impact if reduced to black, gray and white. I depend on washes of watercolor to add the drama of color to my journal, as the subject dictates. Although journal pages do not stand up to wet-on-wet conditions and heavy-handed scrubbing, lightly layered wash applications work quite nicely and allow the artist to achieve a wide range of effects. For a bolder, more vibrant color statement, I may switch to colored pencil, layering complementary colors to produce earth tones and shadows. Even though the color mediums require more supplies, time and labor, they really make journal pages come alive.

The purpose of this chapter is to acquaint you with the qualities of these basic mediums and encourage you to experiment with them, but don't limit yourself. Markers, crayons, roll-on fabric acrylics, and charcoal from a fire pit have all appeared in my journals at one time or another. If it works and it's fun, go for it.

FOUR HORSE HITCH
8 1/2" x 11" (22cm x 28cm)
Horses left to right: Horse 1, no. 2 pencil; horse 2, pen and ink; horse 3, pen and ink tinted with watercolor; horse 4, watercolor wash detailed with colored pencil.

Pencil

1. The tip of a newly sharpened pencil, held upright, produces narrow precise marks which are good for line drawings.

2. The tip of a blunt pencil, angled slightly, provides a softer, wider line which is great for making loose line sketches and for shading. Note the blunt pencil drawing of an old, abandoned trunk.

Increased pressure will cause the value to darken.

Subtle blends are obtained by smudging heavier graphite marks with a finger or eraser.

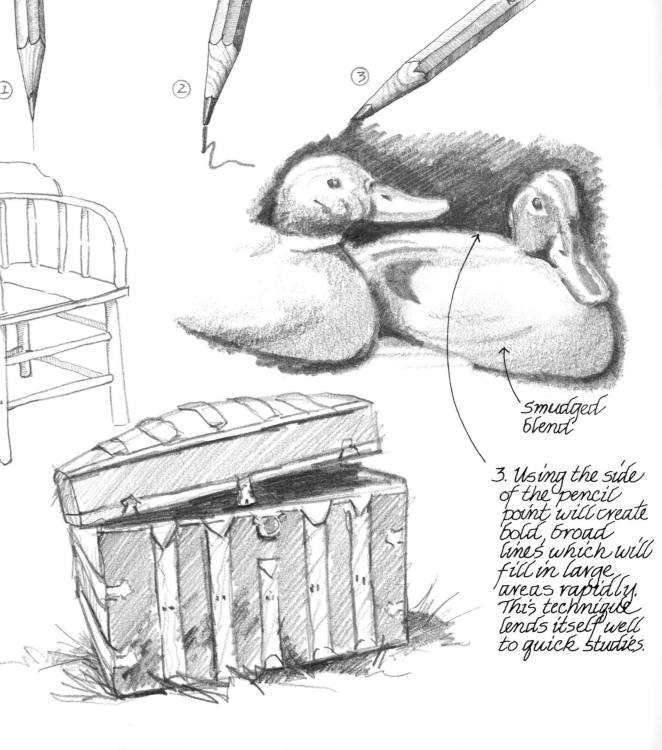

① ② ③

No. 2

smudged blend

3. Using the side of the pencil point will create bold, broad lines which will fill in large areas rapidly. This technique lends itself well to quick studies.

Colored Pencil

In addition to the pencil techniques shown on the previous page, colored pencils can be applied in layers to create vibrant color blends. With just a few pencils of basic hue the artist can produce a wide range of color.

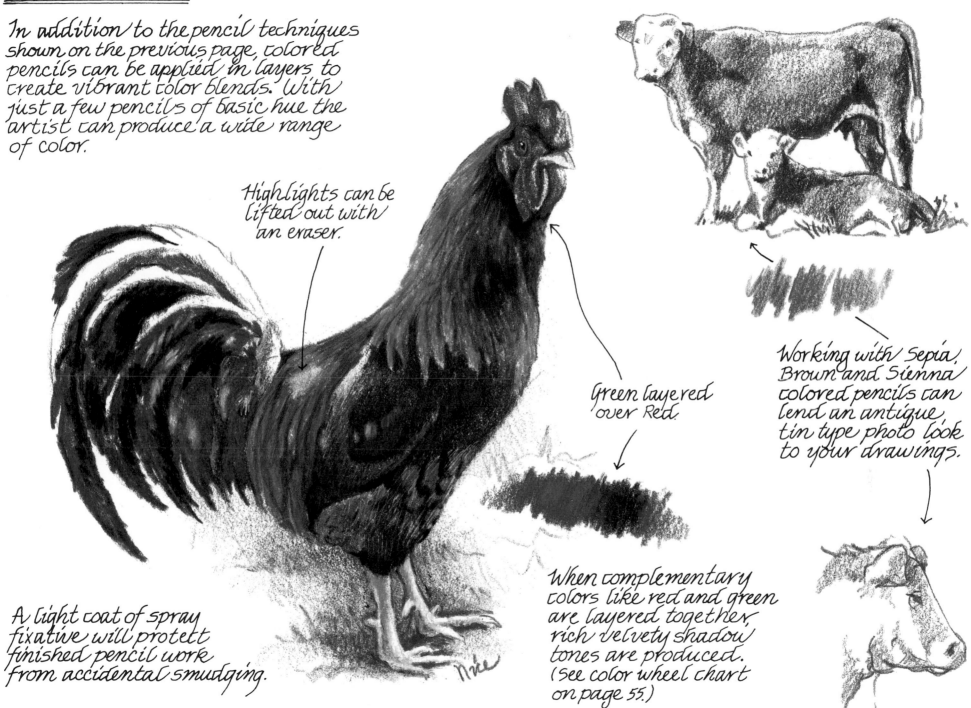

Highlights can be lifted out with an eraser.

Green layered over Red.

Working with Sepia, Brown and Sienna colored pencils can lend an antique, tin type photo look to your drawings.

A light coat of spray fixative will protect finished pencil work from accidental smudging.

When complementary colors like red and green are layered together, rich velvety shadow tones are produced. (See color wheel chart on page 55.)

Pen and Ink

There are basically two types of pen marks that can be set down on paper: Dots and lines. These can be varied in size, shape, volume and arrangement. Pen type, nib size and the artist's personal style all contribute to the overall effect, which can vary greatly.

This precise ink drawing, began with a light pencil sketch to lay out the contours of the subject. A .25 Rapidograph pen was used for the ink work.

A quick-sketch, line drawing need only catch the "essence" of the subject.

.50 Rapidograph Pen.

Here is a loose, scribbly sketch drawn directly in ink using a spiral glass dip pen. Although spontaneous sketches are prone to inaccuracies, they are often the most interesting.

Perfection of form is not always the most important consideration.

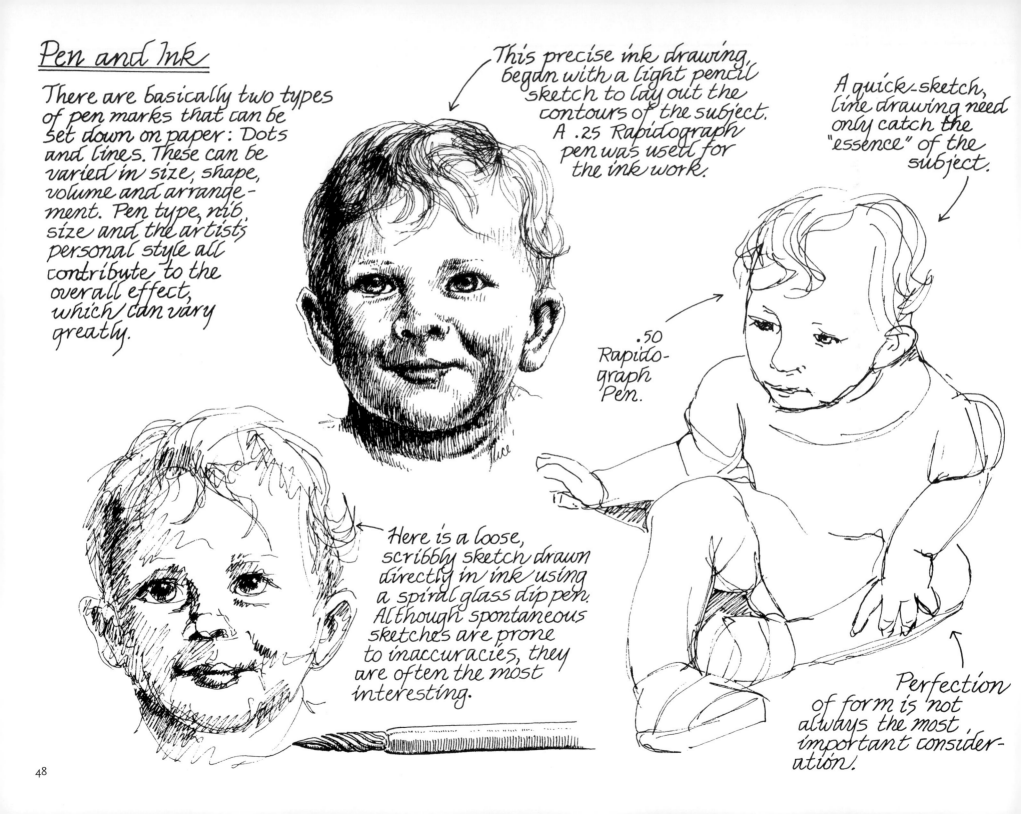

Basic Pen Stroking Techniques

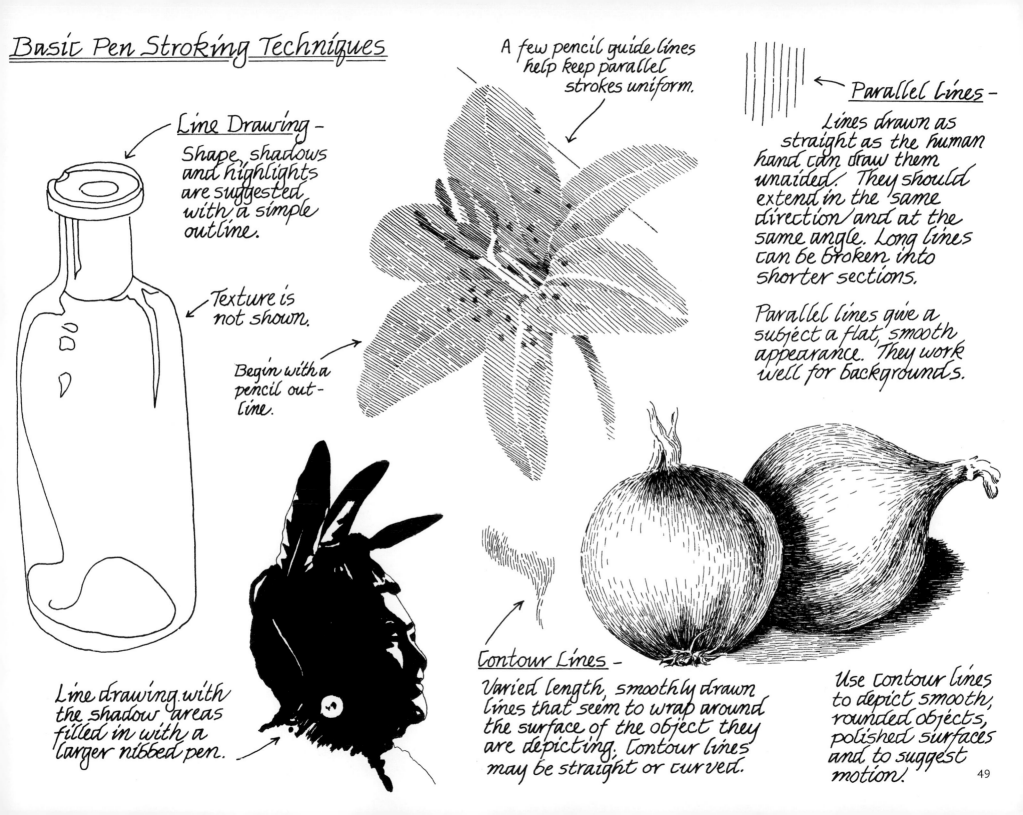

Line Drawing -
Shape, shadows and highlights are suggested with a simple outline.

Texture is not shown.

Begin with a pencil outline.

A few pencil guide lines help keep parallel strokes uniform.

Parallel lines -
Lines drawn as straight as the human hand can draw them unaided. They should extend in the same direction and at the same angle. Long lines can be broken into shorter sections.

Parallel lines give a subject a flat, smooth appearance. They work well for backgrounds.

Line drawing with the shadow areas filled in with a larger nibbed pen.

Contour Lines -
Varied length, smoothly drawn lines that seem to wrap around the surface of the object they are depicting. Contour lines may be straight or curved.

Use contour lines to depict smooth, rounded objects, polished surfaces and to suggest motion.

49

Crisscross Lines-

These are hair-like lines which are set down side by side, each mark at a slightly different angle, so that they cross and overlap in an uneven, random manner. Lines should only be as long as the hairs or grass blades they represent.

Crisscross lines provide a bristly, furry or grass-like texture.

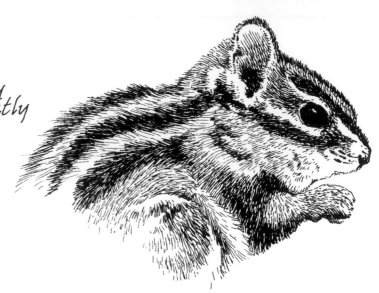

Scribble line texturing

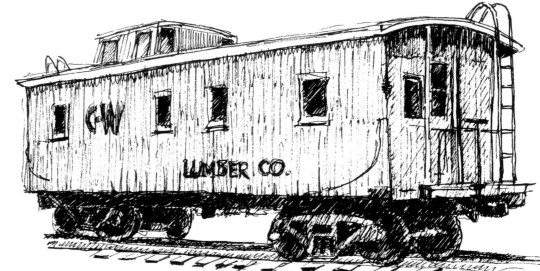

Scribble Lines-
Sketchy lines which loop and twist about in a loose, whimsical manner. When used as a texturing technique, scribble lines have a thick, tangled or matted appearance.

Scribbly lines make great quick sketch studies.

50

Honeycomb crosshatch (three or more sets of lines.)

← Wavy Lines –

Lines that are drawn side by side, forming a grain-like rippling pattern.

Wavy lines are useful for depicting subjects that have repetitive designs such as woodgrain, feather barbs, marble, water rings, and locks of long hair.

When using wavy lines to suggest a grain pattern, add shadows by using a second set of contour, parallel or crosshatched lines.

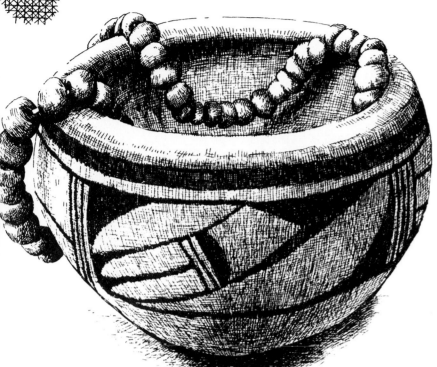

Hatch marks

Parallel line crosshatch

Contour crosshatch

Scribbly crosshatch

← Stippling –

A series of dots produced by touching the pen nib to the paper in a vertical position. Stippling allows the artist to create soft, subtle blends of value.

Crosshatching –

Two or more sets of contour or parallel lines (hatch marks) that are stroked in different directions and intersect. Lines may be long or short, precise or sketchy.

Crosshatching produces a wide variety of textural effects ranging from semi-smooth to very rough, depending on the nib used, precision of line placement and the angle at which the lines intersect.

← Dots work well to depict subjects composed of numerous small particles, delicate transparent objects or to give any subject a dusty, antique look.

Working With a Limited Watercolor Palette

Begin with six intense primary mixing colors.—

 __warm red__

* Cadmium Red, Lt.

 __cool red__

* Quinacridone Rose
 or
 · Thalo Crimson
 · Permanent Carmine
 · Permanent Alizarin Crimson
 · Thio Violet - (This is a step bluer in hue.)

 __warm blue__

* Ultramarine Blue
 or
 · French Ultramarine

 __cool blue__

* Phthalocyanine Blue
 or
 · Thalo Blue
 · Winsor Blue (Green shade)

 __cool yellow__

* Azo Yellow (Aureolin)
 or
 · Cadmium Yellow, Lt.
 · Cadmium Lemon
 · Winsor Lemon

 __warm yellow__

* Cadmium Yellow
 or
 · Cadmium Yellow, Med.
 · New Gamboge

The brands listed above are M. Graham & Co.* (shown in triangle), Grumbacher and Winsor & Newton watercolors.

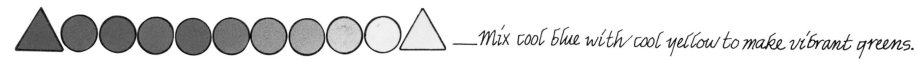 —Mix warm yellow with warm red to make brilliant oranges.

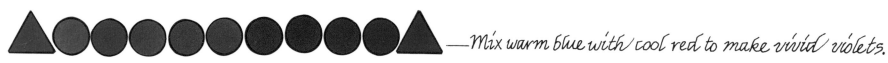 —Mix warm blue with cool red to make vivid violets.

 —Mix cool blue with cool yellow to make vibrant greens.

A medial red, yellow and blue can be produced by mixing the warm and cool representative of each hue!

yellow red blue

Combining complementary colors, those opposite each other on the color wheel, will produce rich, natural shadow colors, clean earthy browns and muted neutral gray-browns. The base color will become increasingly more muted as greater amounts of the complementary color are added, until it becomes neutral gray.

Below are frequently used premixed browns which are convenient to have on hand.

 Sap Green Burnt Sienna Payne's Gray Sepia

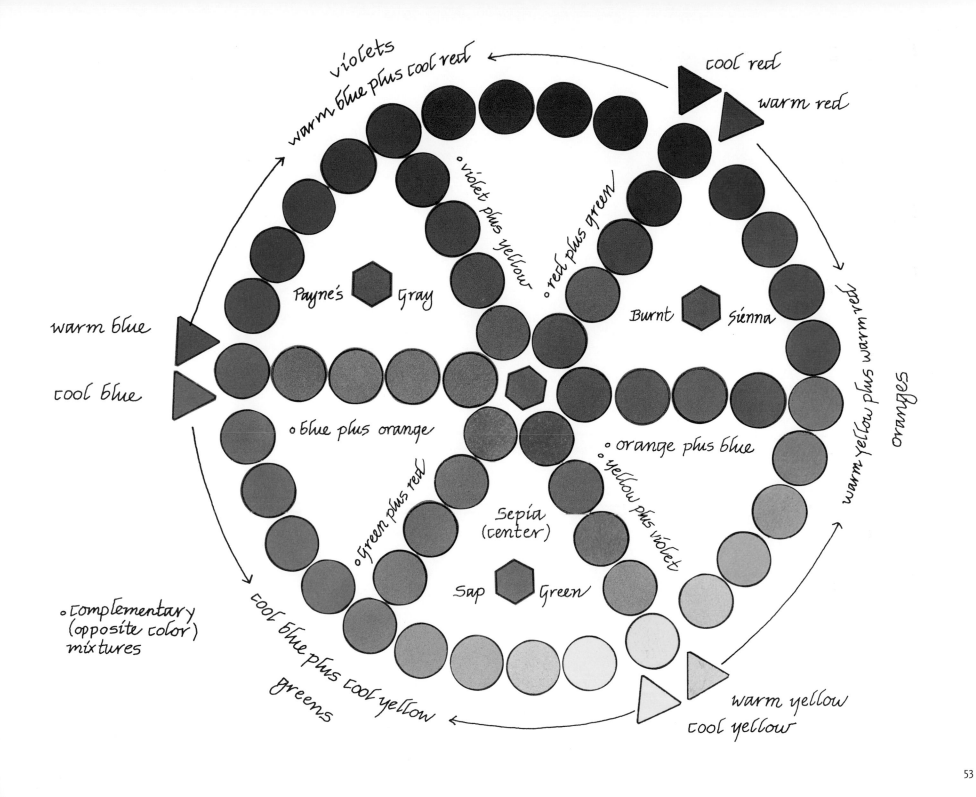

violets
warm blue plus cool red

cool red

warm red

° violet plus yellow

° red plus green

Payne's Gray

Burnt Sienna

warm blue

cool blue

° blue plus orange

° orange plus blue

° green plus red

° yellow plus violet

Sepia (center)

warm yellow plus warm red

oranges

Sap Green

° complementary (opposite color) mixtures

cool blue plus cool yellow

greens

warm yellow

cool yellow

Basic Watercolor Techniques -

The following are watercolor procedures that work well on most sketchbook journal papers.

Flat Wash

Fluid paint, brushed quickly and evenly over a dry surface produces smooth, uniform washes. Avoid over working or "playing" in the wash once it's been applied.

Drybrush

A paint-filled brush is blotted to remove most of the moisture, then applied to a dry surface.

Rough texture

Layering/Glazing

Values may be deepened or colors changed by stroking one wash over another. Allow each wash to dry completely before adding the next.

Thin layers are called glazes.

Lifting

A clean, damp brush stroked through a moist wash will collect and lift pigment, leaving an area of lighter value.

Graded Wash

As a wash is stroked on, more water is added to the brush to lighten the value.

← Hard edge

Softened Or Blended Edge -

The edge of a moist wash may be softened by stroking it with a clean, damp brush. Clean the brush every few strokes.

Note: Sketchbook journal paper is not watercolor paper and will buckle, warp and wear out under heavy moisture and brush work.

Watercolor Texturing Techniques—

Splayed brush
Slightly separate the hairs of a paint-filled, blotted flat brush, so that the tip is splayed out. Wiggle the brush as it moves across the paper to create a rippled woodgrain effect.

Sea sponge

Kitchen sponge

Sponging
Coat a damp sponge with paint and daub or press onto the paper for a soft foliage effect. Kitchen sponges leave holes that look like pebbles.

Spatter
Flick a paint filled brush off your finger tip to produce a spray of paint droplets. The closer you are to the paper, the smaller the pattern.

Water drops spattered into a wet wash dry with a mossy look.

Paper towel

Spatter on a dry surface suggests specks, seeds, sandy soil or an irregular quality.

Spatter in a moist flat wash spreads and softens.

Blotting
Pressing an absorbent material into a moist wash creates designs of lighter value.

Crumpled facial tissue

55

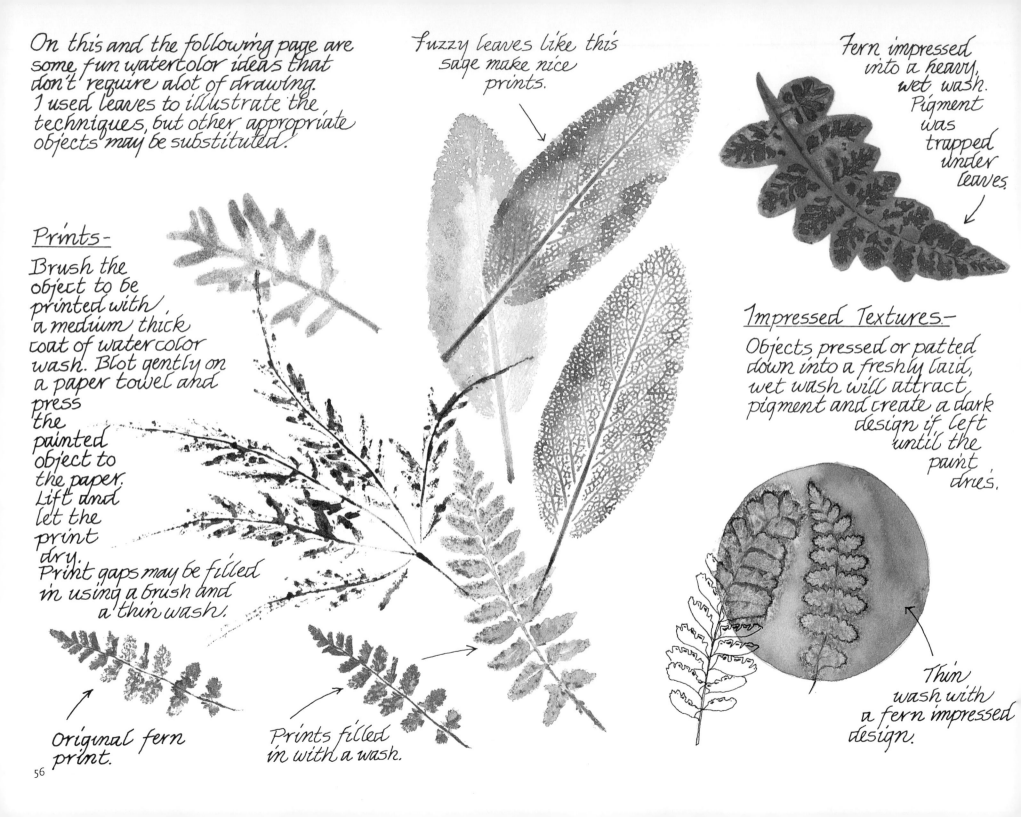

On this and the following page are some fun watercolor ideas that don't require a lot of drawing. I used leaves to illustrate the techniques, but other appropriate objects may be substituted.

fuzzy leaves like this sage make nice prints.

Fern impressed into a heavy, wet wash. Pigment was trapped under leaves.

Prints-

Brush the object to be printed with a medium thick coat of watercolor wash. Blot gently on a paper towel and press the painted object to the paper. Lift and let the print dry. Print gaps may be filled in using a brush and a thin wash.

Impressed Textures-

Objects pressed or patted down into a freshly laid, wet wash will attract pigment and create a dark design if left until the paint dries.

Original fern print.

Prints filled in with a wash.

Thin wash with a fern impressed design.

If you forget your brush try using a twig!

Twig Brushes-

1. Break a five inch long, live twig from a tree.

2. Peel the bark away from the larger end.

3. Pound, mash or chew the end until the wood fibers soften and separate. You now have a rustic paint brush.

Note: Do not chew any twigs unless you know they come from a non-poisonous tree or shrub.

Twig brushes are rough, stiff and willful, producing loose, spontaneous paintings.

Painted with a twig brush.

① ② ③

Shadow Tracings- Place an object between the sun and the paper so that it casts a clear shadow. Trace the outline in pencil or paint it directly in a muted watercolor wash, as a soft back-ground object.

This layered watercolor study began as a shadow tracing.

- - - - - - - - - - - - - - -

a. Brush, sponge or spatter paint on and around the stencil to darken the negative space. Let dry and remove stencil.

6. Tint the white design blocked out by the stencil using a soft round brush and a thin watercolor wash!

Negative Stenciling-

Choose a flat, fairly stiff object for a stencil and secure it to the paper with tiny bits of tape or rubber cement.

ⓐ.

⑥.

Negative space around the fern stencil was sponged on.

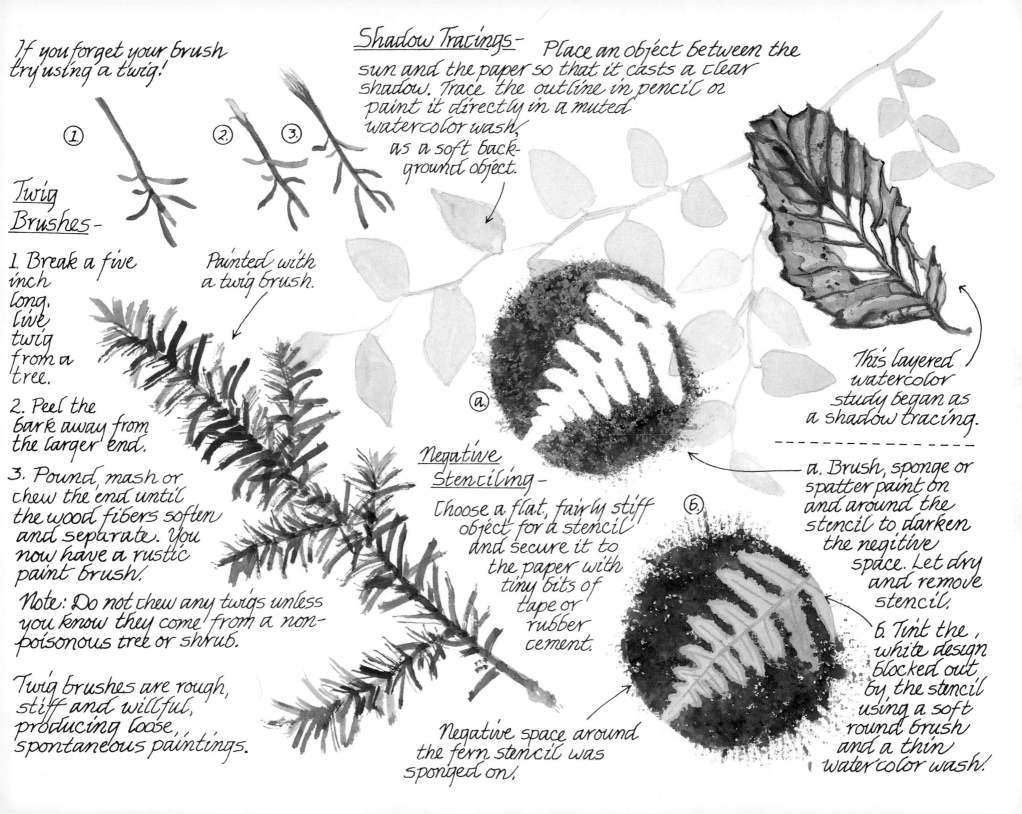

Mixed Media

Once you are familiar with the characteristics of pencil, pen, ink and watercolor, you can combine them to add variety to your sketches.

Burnt Sienna Ink

This fence study is a pen and ink drawing shaded with ink washes applied with a round brush.

India Ink

Rapidograph pen sizes .25 & .50.

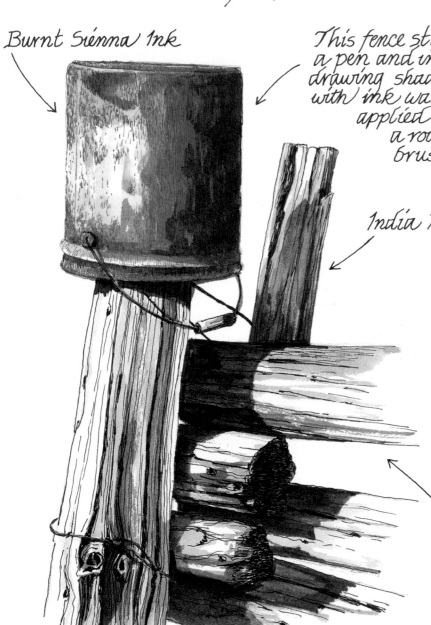

Ink washes are made by diluting India ink or colored ink with water to reach the desired value. Colored inks may be mixed to create new hues and shades.

This cranky old boar was sketched in pen and India Ink, then tinted with washes of watercolor. Browns, Siennas and Ochres were used.

Watercolor base

Layering colored pencil over dry watercolor washes can add a velvety vibrance to florals.

This White-Throated Sparrow drawing began as a quick pen and ink sketch. Wishing to document the bird's color markings, I then added a light application of colored pencil.

Pen nib size .25.

Pen and ink worked thoughtfully over watercolor washes can add definition and emphasize textures. However, too many stiff ink outlines will make a sketch resemble a colorbook drawing.

Pen and ink lines drawn through a moist wash will fray and soften.

This is a quick and easy way for birders to make colored field studies.

There are no set rules on when and how pen, ink, pencil and watercolor can be combined. Experiment! If it works and you like the look, use it often.

Note: I have found that some colored pencils have a waxy quality and tend to repel both ink and watercolor when used as a base or under drawing.

59

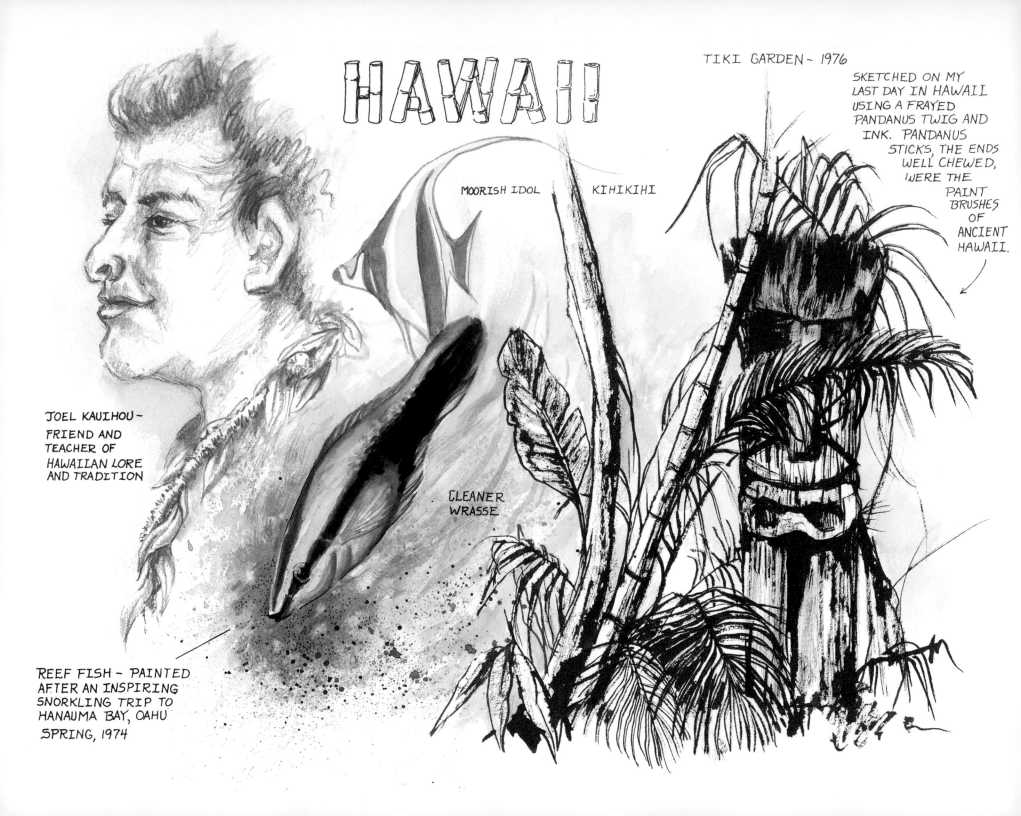

HAWAII

TIKI GARDEN ~ 1976

SKETCHED ON MY LAST DAY IN HAWAII USING A FRAYED PANDANUS TWIG AND INK. PANDANUS STICKS, THE ENDS WELL CHEWED, WERE THE PAINT BRUSHES OF ANCIENT HAWAII.

MOORISH IDOL KIHIKIHI

CLEANER WRASSE

JOEL KAUIHOU ~ FRIEND AND TEACHER OF HAWAIIAN LORE AND TRADITION

REEF FISH ~ PAINTED AFTER AN INSPIRING SNORKLING TRIP TO HANAUMA BAY, OAHU SPRING, 1974

Chapter 4 — The Theme Sketchbook

When a person focuses her attention on one particular subject, a theme sketchbook can be the perfect place to retreat. With such journals, the author can surround herself with subject matter that intrigues her and, through observations and illustrations, can gain greater knowledge and insight.

Through the years I have kept many theme sketchbook journals. The first was created around the Old West and was full of history, Native-American sketches, horses, cattle, barns and so on. My love of the Old West didn't change, but my location did. When my husband and I moved to Hawaii, I made a new title page in my journal and set about recording the Polynesian culture and island scenes. Palm trees, reef fish, tropical birds, beachscapes and native faces began to fill the pages. The things, people and places I observed and illustrated in my book created a desire in me to research the subjects in greater depth. We lived there three years and I learned so much! Aside from the knowledge I gained, the relaxation and enjoyment I received was priceless.

Theme journals can and should change according to your interest. When one theme has served its purpose, write out a new title page and move on to something new. No subject is too common, weird or silly if it is of interest. I had one student who kept a theme book of foot sketches! Why? Because he commuted to work on a bus and people's feet were a readily available and varied subject. He didn't have to stare at anyone's face to draw them. It made a really unusual and interesting theme journal!

In this chapter, I've included some theme journal excerpts and ideas from my journals. Perhaps one of them will pique your interest, but choose strictly according to the dictates of your own will, whim and pleasure.

SOME THEME IDEAS TO CONSIDER:

wildflowers ❀ regional wildlife ❀ zoo animals ❀ family pet sketches ❀ an animal species category ❀ portraits of friends and acquaintances ❀ children ❀ faces with character ❀ a regional or cultural theme ❀ antique objects or collectibles ❀ historical buildings ❀ barns and rustic buildings ❀ fences and stone walls ❀ Victorian houses ❀ cityscapes ❀ churches and temples ❀ country life ❀ landscapes ❀ seascapes ❀ nautical themes ❀ old cars, airplanes or trains ❀ sport heroes and memorabilia ❀ holiday memories

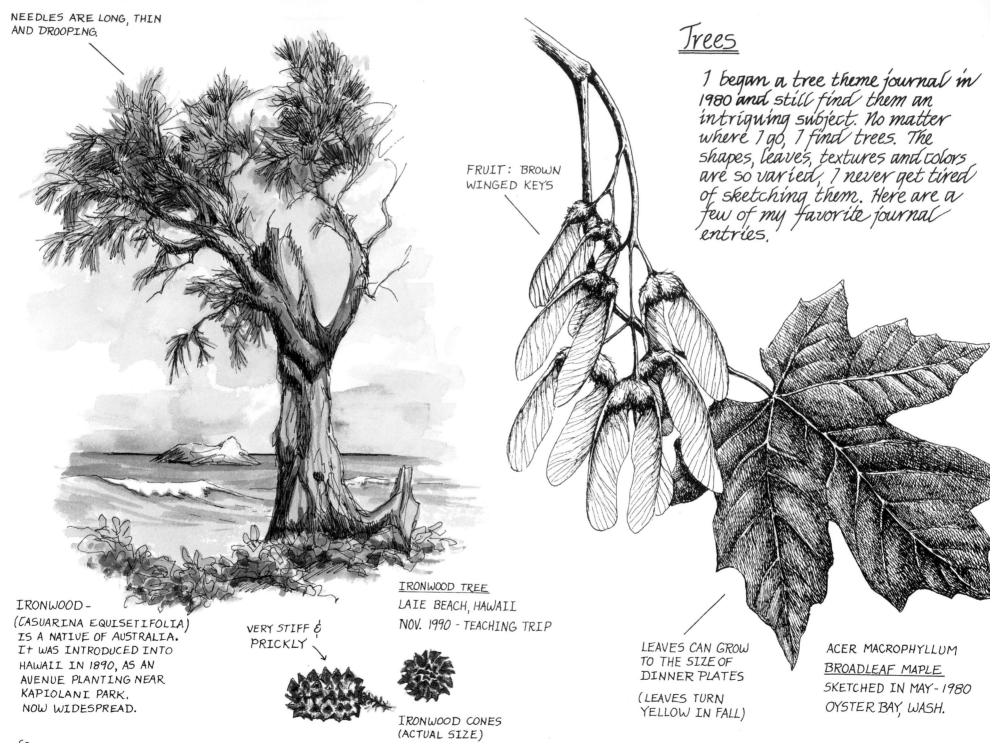

NEEDLES ARE LONG, THIN AND DROOPING.

Trees

I began a tree theme journal in 1980 and still find them an intriguing subject. No matter where I go, I find trees. The shapes, leaves, textures and colors are so varied, I never get tired of sketching them. Here are a few of my favorite journal entries.

FRUIT: BROWN WINGED KEYS

IRONWOOD TREE
LAIE BEACH, HAWAII
NOV. 1990 - TEACHING TRIP

IRONWOOD -
(CASUARINA EQUISETIFOLIA)
IS A NATIVE OF AUSTRALIA.
It WAS INTRODUCED INTO
HAWAII IN 1890, AS AN
AVENUE PLANTING NEAR
KAPIOLANI PARK.
NOW WIDESPREAD.

VERY STIFF & PRICKLY

IRONWOOD CONES
(ACTUAL SIZE)

LEAVES CAN GROW
TO THE SIZE OF
DINNER PLATES

(LEAVES TURN
YELLOW IN FALL)

ACER MACROPHYLLUM
BROADLEAF MAPLE
SKETCHED IN MAY - 1980
OYSTER BAY, WASH.

NOBLE FIR

CHRISTMAS TREE '83

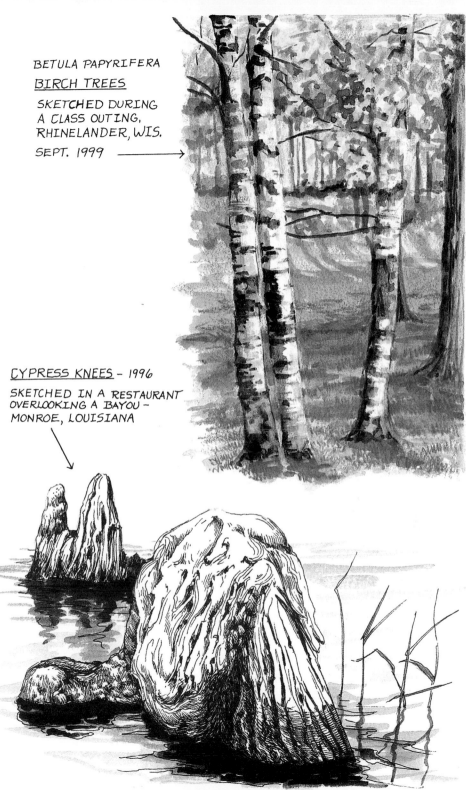

BETULA PAPYRIFERA
BIRCH TREES
SKETCHED DURING A CLASS OUTING, RHINELANDER, WIS. SEPT. 1999 →

CYPRESS KNEES – 1996
SKETCHED IN A RESTAURANT OVERLOOKING A BAYOU – MONROE, LOUISIANA

A Collection of Aged Faces

As bodies grow older, they gain both wrinkles and character. As lives grow older the wisdom they have gathered is often reflected on their faces, making them a truly interesting subject.

Older folk are one subject that requires a little more time to sketch, considering all the character that must be set down on paper. I often take photos and make my journal drawings from them.

Contour lines work well to depict skin folds and wrinkles.

Sketched in Burnt Sienna pencil.

I made this sketch of my grandfather from an old photograph found in a family album. An interesting man I would have liked to meet.

GRANDFATHER
ALBERT WILLIAM FRY
(BORN 1861 - DIED 1946)

1992

BARBARA COOK ~ "THE GARDEN KEEPER"

I WAS ON VACATION WHEN I CAME ACROSS BARBARA PULLING WEEDS AT THE OLYMPIC NATIONAL PARK VISITOR'S CENTER, WA, WHERE SHE WORKS AS A VOLUNTEER.

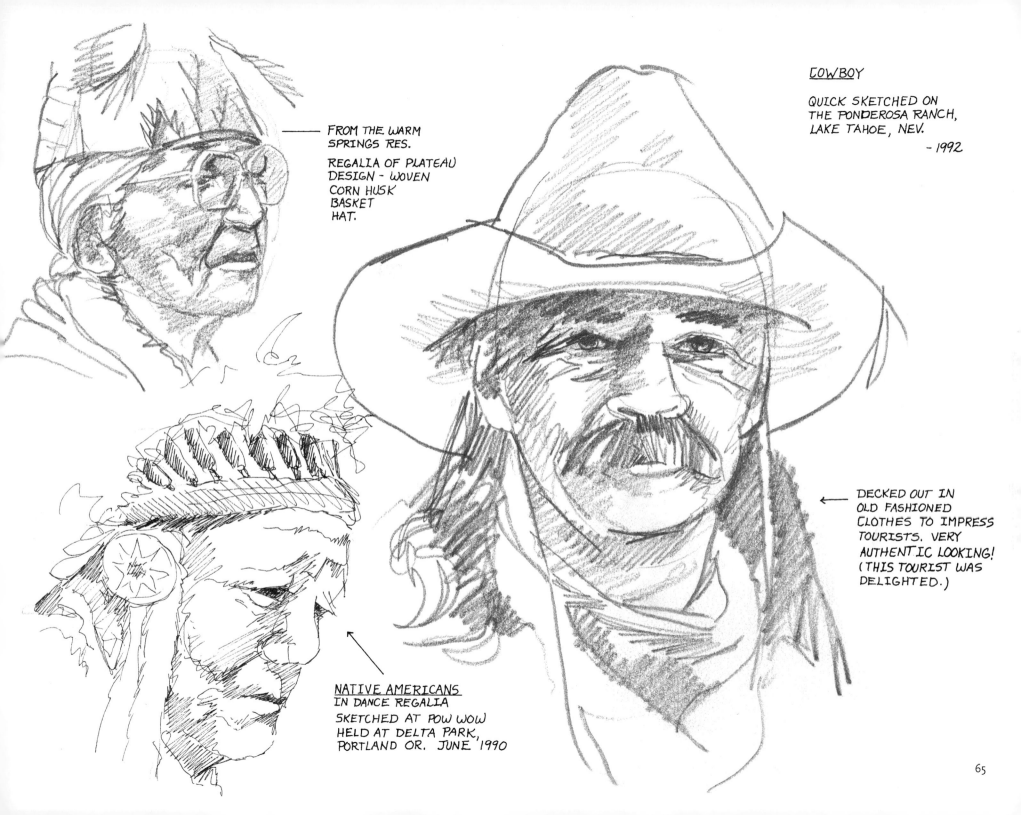

FROM THE WARM
SPRINGS RES.

REGALIA OF PLATEAU
DESIGN - WOVEN
CORN HUSK
BASKET
HAT.

COWBOY

QUICK SKETCHED ON
THE PONDEROSA RANCH,
LAKE TAHOE, NEV.

 - 1992

DECKED OUT IN
OLD FASHIONED
CLOTHES TO IMPRESS
TOURISTS. VERY
AUTHENTIC LOOKING!
(THIS TOURIST WAS
DELIGHTED.)

NATIVE AMERICANS
IN DANCE REGALIA

SKETCHED AT POW WOW
HELD AT DELTA PARK,
PORTLAND OR. JUNE '1990

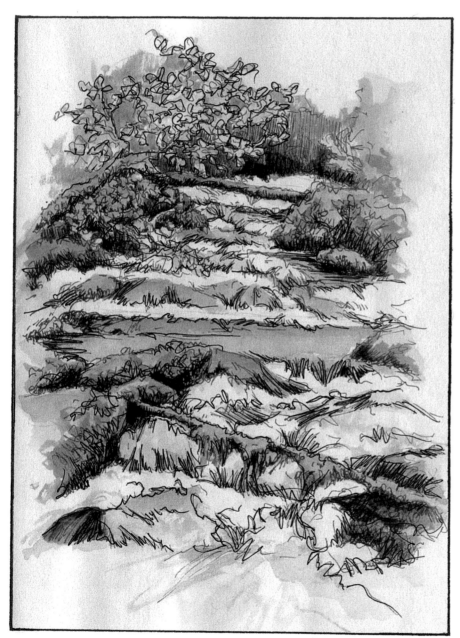

<u>OLALLIE CREEK</u> – JUST ABOVE WHERE IT FLOWS INTO THE McKENZIE RIVER, SOUTHERN OREGON.

SEPTEMBER 1995 – (VACATION CAMPING TRIP)

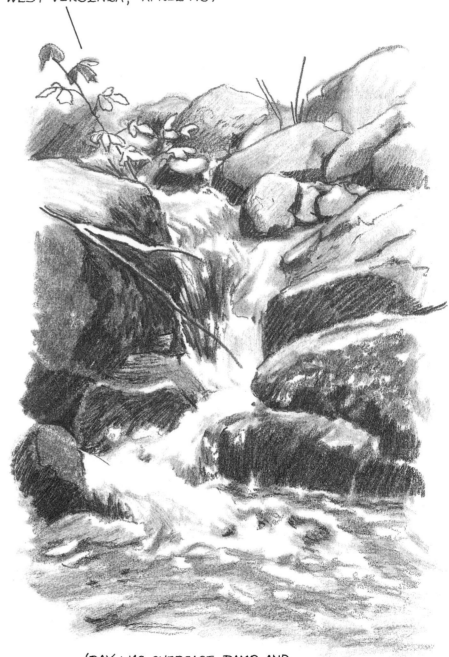

(DAY WAS OVERCAST, DAMP AND COLD. CLASS WAS SUPPOSED TO GO TO BLENNER HASSETT ISLAND TO SKETCH. ENDED UP AT MT. WOOD PARK.)

Waterscapes

Although I never devoted an entire journal to the illustration of creeks, rivers and water falls, perhaps I should have. Waterscapes have always been a popular artistic subject. Here are some of my favorite white water drawings, from among the creek entries found in my journals.

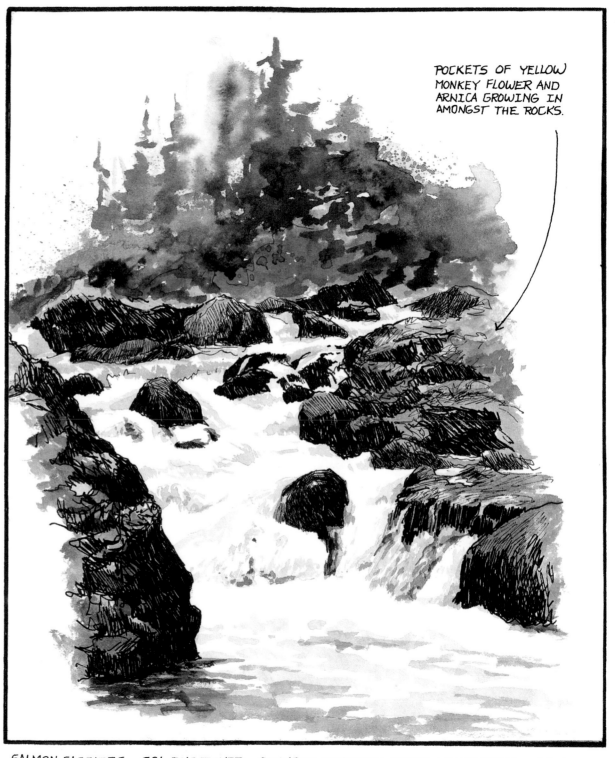

POCKETS OF YELLOW MONKEY FLOWER AND ARNICA GROWING IN AMONGST THE ROCKS.

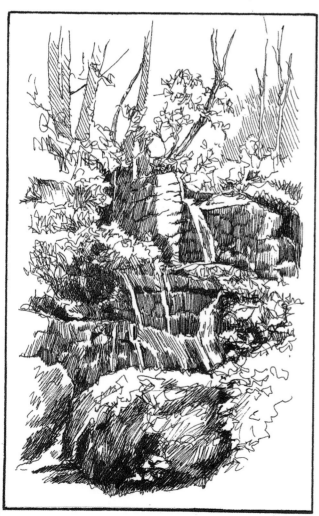

ROARING FORK FALLS, SMOKEY MTS., NORTH CAROLINA
MAY 1996

SALMON CASCADES, SOL DUC RIVER, OLYMPIC NATIONAL PARK, WASHINGTON – AUGUST 1982

Dogs and Cats

Dogs provide a never ending source of varied subject matter. I've sketched them in the park, on the beach, along city streets, in yards and in the homes of friends. Most owners are more than willing to leash or hold them while you draw.

Cats are a little more shy. It's best to sketch them while they are resting in familar surroundings.

This detailed ink drawing was made using both the journal entry and a photo for reference. It took an hour to complete.

OUR CHOW PUPPY – <u>CINDERS</u>

6 MONTHS OLD

BLACK, WHITE AND BROWN SPOTTED COAT, FLECKED WITH BLACK.

This journal entry, quick sketched in pencil and watercolor on location, took under ten minutes to complete.

Colored pencil

<u>ROUGH COLLIE MIX</u>
SKETCHED DURING VACATION TRIP TO KENTUCKY – 1996

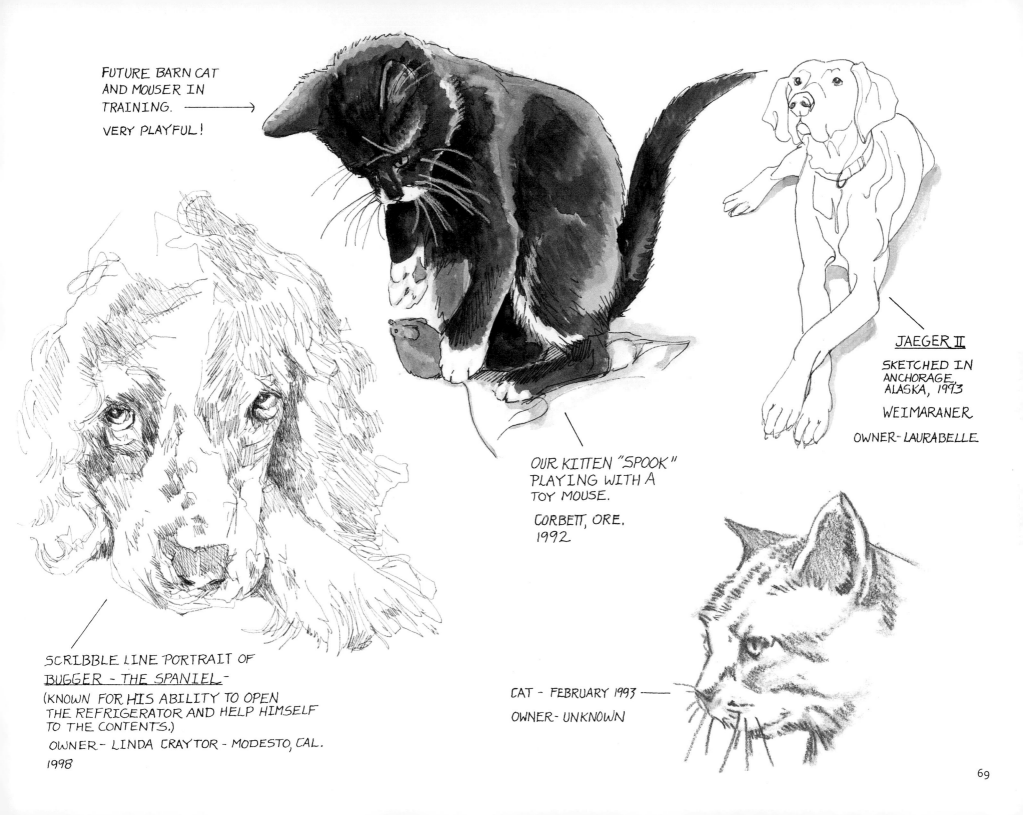

FUTURE BARN CAT
AND MOUSER IN
TRAINING. ———————>
VERY PLAYFUL!

JAEGER II

SKETCHED IN
ANCHORAGE,
ALASKA, 1993

WEIMARANER

OWNER- LAURABELLE

OUR KITTEN "SPOOK"
PLAYING WITH A
TOY MOUSE.

CORBETT, ORE.
1992

SCRIBBLE LINE PORTRAIT OF
BUGGER - THE SPANIEL -
(KNOWN FOR HIS ABILITY TO OPEN
THE REFRIGERATOR AND HELP HIMSELF
TO THE CONTENTS.)
OWNER - LINDA CRAYTOR - MODESTO, CAL.
1998

CAT - FEBRUARY 1993 ———
OWNER - UNKNOWN

EARLY SPRING PLANTINGS

1999

LAST FROST IN OUR MOUNTAIN VALLEY – MAY 10. MAY WEATHER COOL AND WET – LITTLE SUN

PLANTED PEAS, LETTUCE AND SPINACH MAY 1.
 LETTUCE AND SPINACH UP, BUT GROWING VERY SLOW.
 ONLY TWO PEA PLANTS GERMINATED – TOO WET!

PLANTED NASTURTIUMS MAY 8
 GERMINATED AND UP 15 DAYS LATER · DOING WELL

ORDERED NON-HYBRID GARDEN SEED
TO TRY NEXT YEAR.

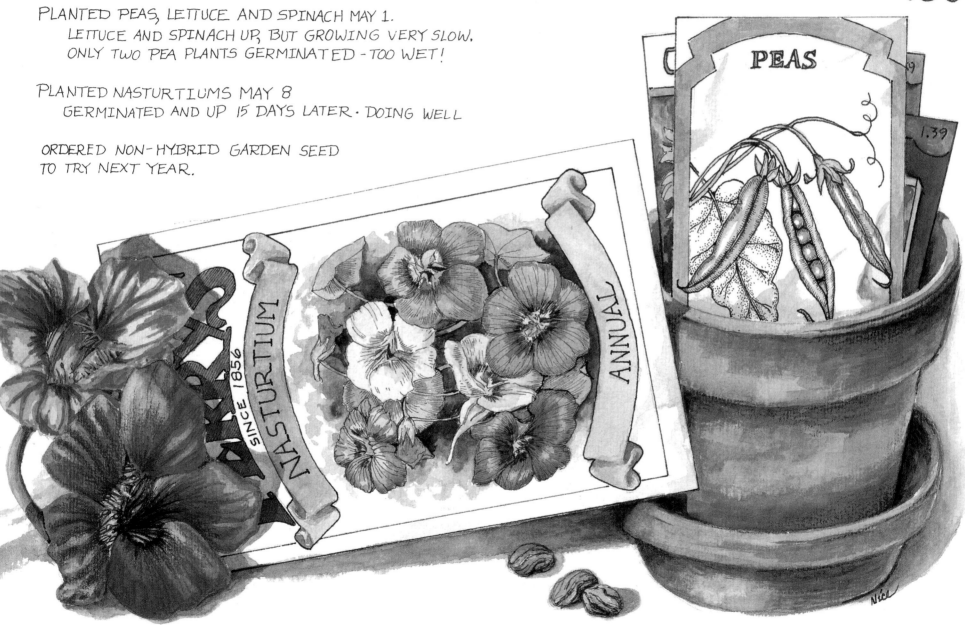

Chapter 5 – A Creative, Colorful Garden Journal

Grandma Celesta's vegetable garden was an important part of her life, and because of her efforts, it grew well. She knew the old-fashioned ways, planting by the moon and raising her own source of fertilizer, the chickens. Grandma kept a garden journal of sorts. She marked the weather (especially frost dates), planting days and harvest dates on the current feed store calendar. When Grandma passed on, the farm journal was kept, but the calendar was tossed. Why? The notations seemed common and impersonal, like a gathering of spent leaves blown against the fence row.

Garden journals can be so much more than statistical records. The record keeper can add a bit of himself by including garden favorites, who gave him the daylily starts, the day the deer ate the roses and how he got the prize-winning pumpkin to grow so huge. Now take it a step further and add some illustrations. They can be as simple as stick figures and rough diagrams, or as elaborate as the spring planting record shown on the opposite page. Skill has importance at an art show, but it is not a consideration on the pages of a garden sketchbook journal. Add personal sketches, shadow tracings, leaf prints or whatever and you add creativity, color and charm. In other words, you make it fun—a work of art to be appreciated long after your gardening days have ended.

IDEAS YOU MAY WANT TO INCLUDE IN YOUR GARDEN JOURNAL

landscape layouts and construction plans ✹ location of perennial plants, bulbs, etc. ✹ reference notes on weather and frost dates ✹ information on newly introduced plants and bulbs ✹ seed planting data (what, where and results) ✹ garden growth and season-to-season changes ✹ garden embellishments (statues, fences, arbors, etc.) ✹ future landscape and project ideas ✹ documentation of pests, weeds and plant diseases ✹ records of fertilizer, sprays and remedies used ✹ pruning and propagation notes ✹ illustrations of bird and butterfly visitors ✹ favorite tools, gloves, sprinklers, etc. ✹ rock, water, bog and other specialty gardens ✹ houseplants and floral arrangements ✹ uses for herbs and edible plants ✹ harvest and bloom records ✹ studies of your floral favorites ✹ wildflowers sketched on location ✹ helpful hints, quotes and folklore

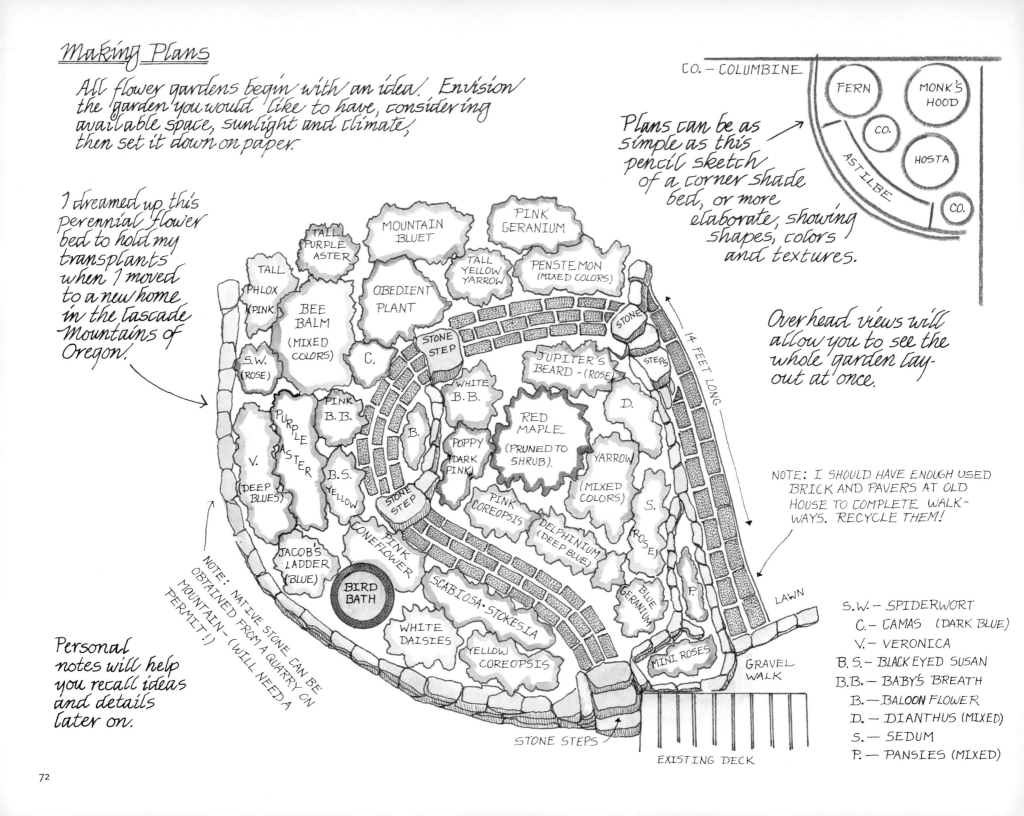

Making Plans

All flower gardens begin with an idea. Envision the garden you would like to have, considering available space, sunlight and climate, then set it down on paper.

I dreamed up this perennial flower bed to hold my transplants when I moved to a new home in the Cascade Mountains of Oregon.

Personal notes will help you recall ideas and details later on.

Plans can be as simple as this pencil sketch of a corner shade bed, or more elaborate, showing shapes, colors and textures.

Overhead views will allow you to see the whole garden layout at once.

NOTE: I SHOULD HAVE ENOUGH USED BRICK AND PAVERS AT OLD HOUSE TO COMPLETE WALKWAYS. RECYCLE THEM!

NOTE: NATIVE STONE CAN BE OBTAINED FROM A QUARRY ON MOUNTAIN — (WILL NEED A PERMIT!)

CO. — COLUMBINE

FERN
MONK'S HOOD
CO.
HOSTA
ASTILBE
CO.

PINK GERANIUM
MOUNTAIN BLUET
TALL PURPLE ASTER
TALL YELLOW YARROW
PENSTEMON (MIXED COLORS)
TALL PHLOX (PINK)
BEE BALM (MIXED COLORS)
OBEDIENT PLANT
STONE STEP
STONE
STEPS
14 FEET LONG
S.W. (ROSE)
C.
JUPITER'S BEARD — (ROSE)
WHITE B.B.
D.
PINK B.B.
PURPLE ASTER
B.
POPPY (DARK PINK)
RED MAPLE (PRUNED TO SHRUB).
YARROW (MIXED COLORS)
V. (DEEP BLUES)
B.S. YELLOW
STONE STEP
PINK COREOPSIS
DELPHINIUM (DEEP BLUE)
S. (ROSE)
JACOB'S LADDER (BLUE)
PINK CONEFLOWER
BIRD BATH
SCABIOSA · STOKESIA
BLUE GERANIUM
P.
LAWN
WHITE DAISIES
YELLOW COREOPSIS
MINI ROSES
GRAVEL WALK
STONE STEPS
EXISTING DECK

S.W. — SPIDERWORT
C. — CAMAS (DARK BLUE)
V. — VERONICA
B.S. — BLACK EYED SUSAN
B.B. — BABY'S BREATH
B. — BALOON FLOWER
D. — DIANTHUS (MIXED)
S. — SEDUM
P. — PANSIES (MIXED)

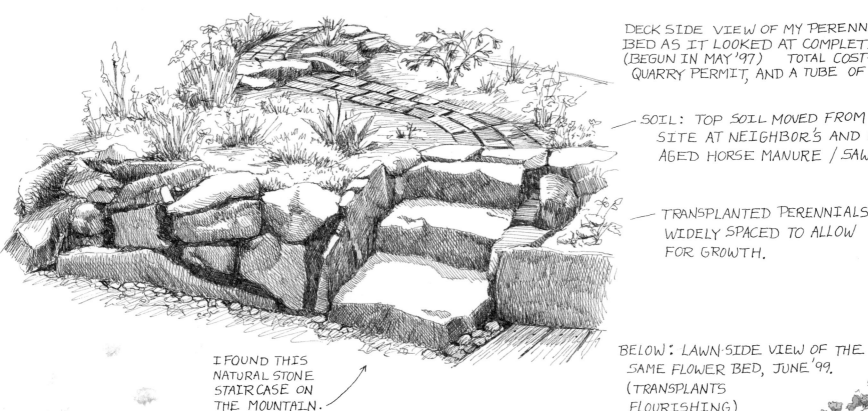

DECK SIDE VIEW OF MY PERENNIAL FLOWER-
BED AS IT LOOKED AT COMPLETION, AUG.'97.
(BEGUN IN MAY '97) TOTAL COST- $25.00 FOR
QUARRY PERMIT, AND A TUBE OF LINIMENT.

SOIL: TOP SOIL MOVED FROM CONSTRUCTION
SITE AT NEIGHBOR'S AND MIXED WITH
AGED HORSE MANURE / SAWDUST.

TRANSPLANTED PERENNIALS
WIDELY SPACED TO ALLOW
FOR GROWTH.

I FOUND THIS
NATURAL STONE
STAIRCASE ON
THE MOUNTAIN.

BELOW: LAWN-SIDE VIEW OF THE
SAME FLOWER BED, JUNE '99.
(TRANSPLANTS
FLOURISHING)

A RUSTED BEDSTEAD
FOUND IN THE FOREST
WAS ADDED FOR
PLANT SUPPORT AND
A TOUCH OF WHIMSEY.

UNEXPECTED
PAW PRINTS FROM
MY CAT SPOOK ---
ONE OF THE
HAZZARDS OF
SKETCHING ON
LOCATION.

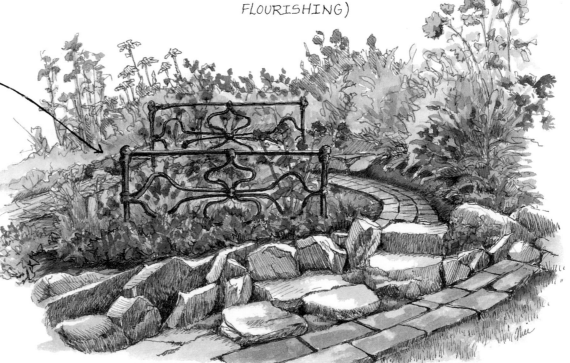

Garden Embellishments

Once the garden is planted and growing, it's time to add the touches that make it your own! Whether you find, make or buy your garden decorations, don't miss the fun of recording them in your garden Journal.

Sketching this gate was easier for me than building it!

THIS IS HOW I ENVISION IT WILL LOOK IN A COUPLE YEARS.

COMMON HONEYSUCKLE (LONICERA PERICLYMENUM BELGICA)

DROPMORE SCARLET (LONICERA BROWNII)

JUNE '98
I BOUGHT THESE TWO HONEYSUCKLE VINES TO CLIMB THE ARBOR OVER THE GATE. ($12.95 ea.)

JUNE '99 - VINES HAVE REACHED THE TOP OF THE ARBOR. - (GROWING WELL)

I BUILT THE STICK GATE OUT OF TWISTED WILLOW BRANCHES FROM A STORM DAMAGED TREE. AN INEXPENSIVE METAL ARCH FORMS THE ARBOR FRAME WORK.

Pests and Problems

To conquer enemies and solve problems, you first have to recognize them! On this page I have documented two of my greatest gardening challenges.

SNAIL AND SLUG EATING LETTUCE (ACTUAL SIZE)

FAVORITE PLANTS ON THE SLUG MENU INCLUDE PANSIES, DAHLIAS, CANDYTUFT, MONKEY FLOWER (MIMULUS), LILIES AND SPREADING PHLOX.

FAVORITE HIDING PLACE: THE ROCK GARDEN!

EMPTY SHELL

GARDEN ENEMY NO 1!

THESE GUYS CAN MOVE OFF PRETTY QUICK. THIS ONE CRAWLED OVER 8 INCHES IN LESS THAN A MINUTE.

BLACK SPOT

EARLY JUNE '99. FOUND BLACK SPOT ON LOWER LEAVES OF MATADOR ROSE.

REMOVED INFECTED LEAVES. SO FAR THE OTHER ROSES ARE NOT DISEASED.

4½ INCHES LONG

I HAVE TRIED STOPPING SLUG AND SNAIL DAMAGE USING BAIT, BEER TRAPS, DIATOMACEOUS EARTH AND COPPER BARRIERS, WITH VARIED SUCCESS. HAND REMOVING AT NIGHT, BY FLASHLIGHT, WORKS BEST. DURING THE SUMMER OF 1998, I AVERAGED 155 PER NIGHT. THIS YEAR (1999), THERE ARE ALOT FEWER SLIMY MENACES.

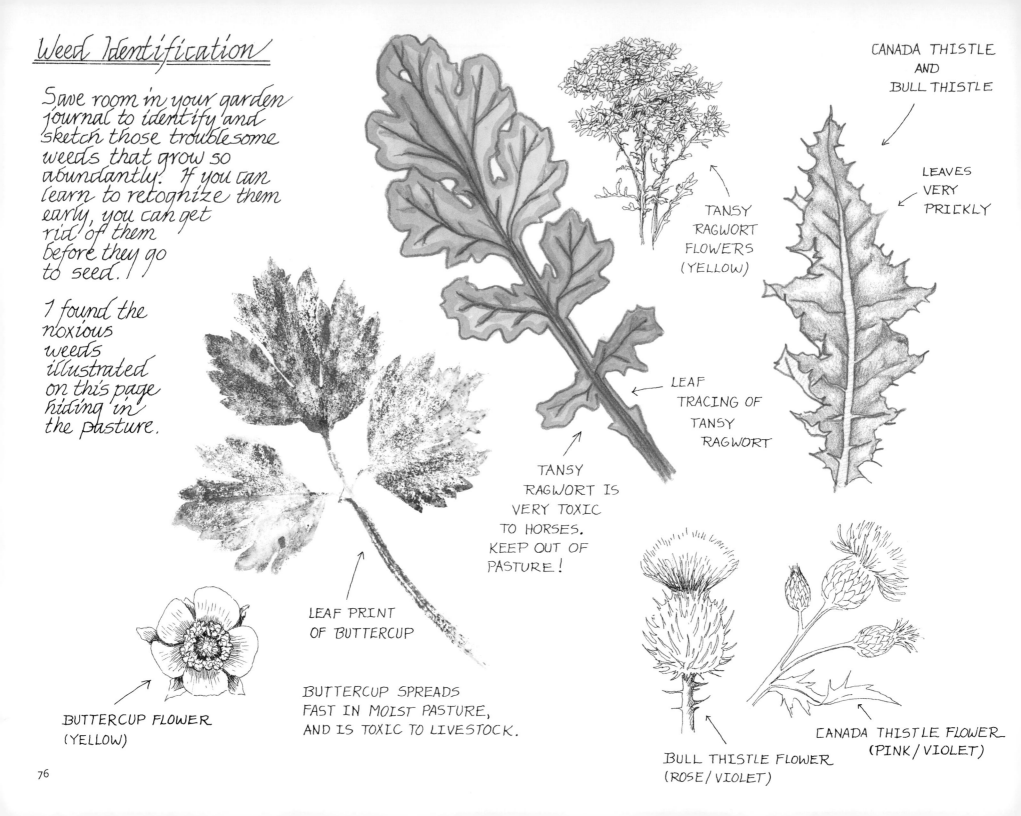

Weed Identification

Save room in your garden journal to identify and sketch those troublesome weeds that grow so abundantly. If you can learn to recognize them early, you can get rid of them before they go to seed.

I found the noxious weeds illustrated on this page hiding in the pasture.

TANSY RAGWORT FLOWERS (YELLOW)

CANADA THISTLE AND BULL THISTLE

LEAVES VERY PRICKLY

LEAF TRACING OF TANSY RAGWORT

TANSY RAGWORT IS VERY TOXIC TO HORSES. KEEP OUT OF PASTURE!

LEAF PRINT OF BUTTERCUP

BUTTERCUP SPREADS FAST IN MOIST PASTURE, AND IS TOXIC TO LIVESTOCK.

BUTTERCUP FLOWER (YELLOW)

BULL THISTLE FLOWER (ROSE/VIOLET)

CANADA THISTLE FLOWER (PINK/VIOLET)

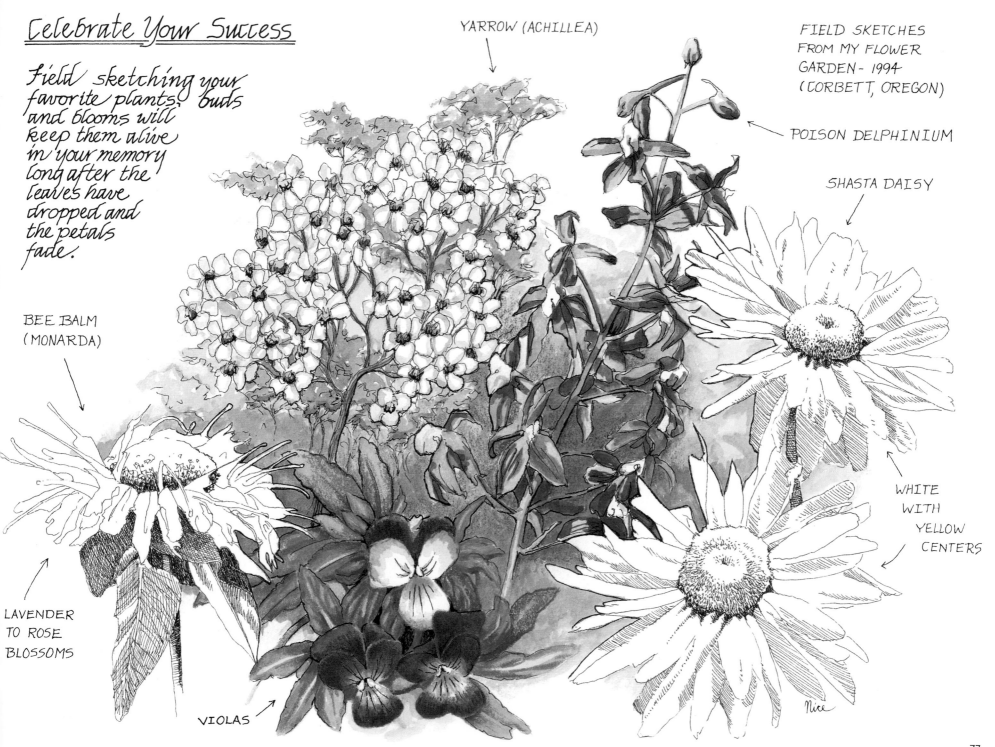

Celebrate Your Success

Field sketching your favorite plants, buds and blooms will keep them alive in your memory long after the leaves have dropped and the petals fade.

YARROW (ACHILLEA)

FIELD SKETCHES FROM MY FLOWER GARDEN - 1994 (CORBETT, OREGON)

POISON DELPHINIUM

SHASTA DAISY

BEE BALM (MONARDA)

LAVENDER TO ROSE BLOSSOMS

VIOLAS

WHITE WITH YELLOW CENTERS

Nice

77

The Corps Of Discovery

girth of the neck 7½ Inches; do. of body exclusive of the wings 2 feet 3 Inches; do. of leg

9 inches. diameter 4½ /10ths of an inch.

of the eye the iris of the puple or black and occupyed of the diameter of the and a part of the figures 1. 2. is uncovered

a pale **scarlet** red. of deep sea green about one third eye. the head neck as low as the with feathers ex=

=cept that portion of it represented by dots (see lit

the tail is composed of 12 feathers of equal le

the leaflet in which the upper

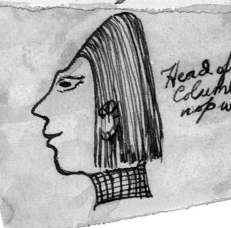

Head of Flat head Indians on the Columbia. the head brought top nop wise

Chapter 6 — A Sketchbook of Discovery

In the spring of 1804 the Corps of Discovery, with the sanction of the United States Government, set off on the first official exploration of the unknown Northwest territories. They were led by Meriwether Lewis and William Clark. At the request of President Thomas Jefferson, all able party members were to maintain separate, detailed journals. On the pages of those weathered notebooks, their adventures and discoveries were so carefully documented that, upon their return, an excited nation would take up the cry of "go west, young man!" On the preceding page I have re-created some excerpts from the original Lewis and Clark journals.

Curious to find out if modern explorers also kept written journals, I contacted astronaut Don Lind, who was a mission specialist aboard the April 1985 flight of the space shuttle Challenger. He explained that all notes and observations were tape-recorded on a special channel reserved for that purpose. As he put it, "you just couldn't have journals floating around loose." It seems that in most cases, the accuracy and convenience of audio and video recorders have replaced the handwritten explorer's journal. However, when you consider charm and old-fashioned pleasure, journals are still in style.

You do not have to be a renowned explorer to keep a discovery journal. If you are willing to slow down and view your surroundings with a childlike curiosity, you will make lots of personal discoveries, gaining a better understanding of the world around you at the same time.

There are still plenty of lost treasures to be found, relics to be uncovered and the rarely sighted to be seen. With a little luck, the next entry in your journal could be the find of your life.

PLACES TO CONSIDER EXPLORING

attics and antique shops ❊ museums ❊ zoos and wildlife parks ❊ interpretive centers ❊ gardens and arboretums ❊ national and state parks ❊ historical parks ❊ ruins ❊ archeological digs ❊ ghost towns ❊ geological sites ❊ unique ecosystems, including mountains, deserts, jungles, swamps and so on ❊ fossil beds ❊ caves ❊ waterways ❊ shorelines and tide pools ❊ the sea (above and below) ❊ the sky and beyond ❊ microscopic worlds ❊ big cities ❊ rural communities ❊ foreign lands ❊ uncharted wilderness ❊ your own backyard

Trail of Discovery

This discovery trip covered familiar ground in the wilderness forest land behind my house. Although I walk these trails almost daily, this particular time I slowed down and opened my eyes a little wider. Here's what I discovered. (Being winter, I gathered the items and returned to the warmth and comfort of my studio to record them).

ITEMS FOUND ALONG THE TRAILS IN THE FOREST BEHIND MY HOME, B.L.M. LAND, BRIGHTWOOD VALLEY, HOODLAND CORRIDOR, OR.

DATE: DECEMBER 28, 1999 — (AFTER NOON)

WEATHER: CALM, CLEAR AND COOL — (LOW 50's)
A WIND STORM HAS BLOWN THROUGH, KNOCKING DOWN TREE BRANCHES AND STIRRING UP THE FALLEN LEAVES.

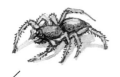

JUMPING SPIDER

(TWICE ACTUAL SIZE)

THIS LITTLE ARACHNID JUMPED OUT FROM THE LICHEN I WAS SKETCHING AND LANDED ON MY DRAWING SURFACE. A SURPRISE DISCOVERY!

FROM WHAT I OBSERVED IT SEEMS TO BE FROM THE FAMILY SALTICIDAE — (JUMPING SPIDERS)

RESOURCE USED: THE AUDUBON SOCIETY FIELD GUIDE TO NORTH AMERICAN INSECTS AND SPIDERS.

DENSELY TANGLED LEAVES

UNDER SURFACE IS DARK & SHINY

A LEAF LICHEN OF THE FAMILY HYPOGYMNIA. FAMILY INCLUDES FORKING BONE LICHEN, FORKING TUBE LICHEN AND TICKERTAPE BONE LICHEN WHICH ALL LOOK SIMILAR TO THIS. (ACTUAL SIZE)

ENGLISH HOLLY BERRIES

NOT NATIVE, ALTHOUGH SEVERAL NICE SIZED HOLLY TREES ARE GROWING WILD AT THE EDGE OF THE FOREST.

REFERENCE: A FIELD MANUAL OF FERNS AND FERN-ALLIES OF THE UNITED STATES & CANADA. — LELLINGER

RAGBAG LICHEN
PLATISMATIA GLAUCA
(ACTUAL SIZE)

CONE FROM A WESTERN HEMLOCK TREE. (ACTUAL SIZE)

DISCARDED LAND SNAIL SHELLS — (NOTHING LIVING INSIDE).
ACTUAL SIZE.

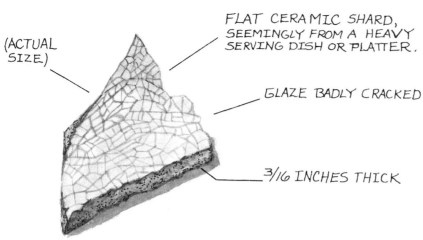

(ACTUAL SIZE)

FLAT CERAMIC SHARD, SEEMINGLY FROM A HEAVY SERVING DISH OR PLATTER.

GLAZE BADLY CRACKED

3/16 INCHES THICK

BROKEN POTTERY PIECES

THESE CROCKERY SHARDS WORKED THEIR WAY UP THROUGH THE SOIL, WHERE I FOUND THEM PARTIALLY EXPOSED IN THE MIDDLE OF THE TRAIL. THEY MAY HAVE BELONGED TO EARLY SETTLERS. OR PIONEERS WHO RESTED IN THIS VALLEY AFTER CROSSING MT. HOOD.

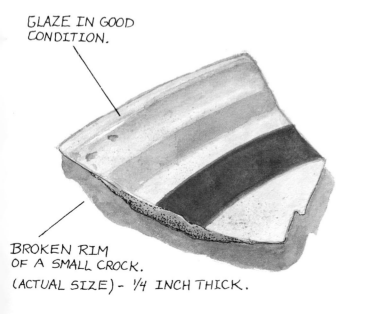

GLAZE IN GOOD CONDITION.

BROKEN RIM OF A SMALL CROCK. (ACTUAL SIZE) - 1/4 INCH THICK.

CAP IS WOODY AND TOUGH. VERY DRY AND CRACKED.

THE DOUBLE CONK MEASURED —

11 INCHES LONG
7½ INCHES WIDE
4½ INCHES THICK

THE WHITE UNDER-SURFACE OF THE CONK WILL DARKEN PERMANENTLY WHEN BRUISED, PROVIDING AN INTERESTING ART SURFACE.

ARTIST'S CONK
GANODERMA APPLANATUM

THIS LARGE SHELF FUNGUS WAS GROWING ON A DEAD CONIFER LOG, SUSPENDED OVER A SEASONAL CREEK. A RECENT FLOOD HAD TORN THE FUNGUS LOOSE.

Beachcombing

Walking the beaches, listening to the sound of the surf and gathering bits of this and that is a favorite discovery activity of mine. Through the years I have found many treasures. Here's a sampling from various journals.

FLORIDA COQUINA SHELLS
MARCO ISLAND
1986

JAPANESE GLASS FLOAT - 1964
FOUND AT MOCLIPS
WASHINGTON

SHELLS SKETCHED ON GALVESTON BEACH
TEXAS 1988

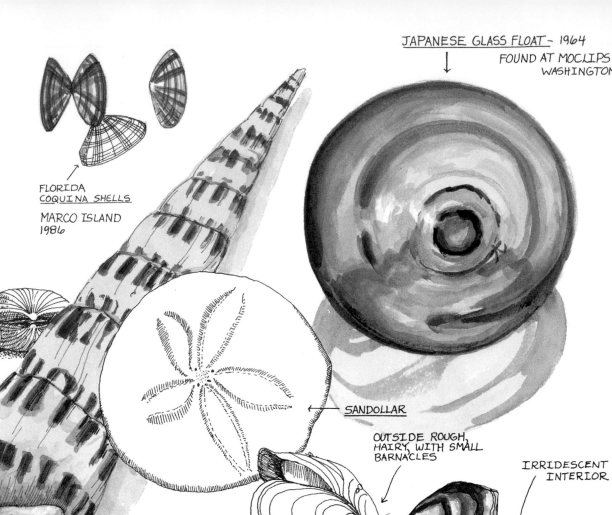

SANDOLLAR

OUTSIDE ROUGH, HAIRY, WITH SMALL BARNACLES

IRRIDESCENT INTERIOR

CARNELIAN

CLEAR GRAY

AUGER SHELL
FOUND IN THE SURF,
NANAKULI, HAWAII
1976

BLUE MUSSELS
CAPE LOOKOUT, OR.
1995

AGATE VEINS

AGATES - FOUND AT CAPE LOOKOUT
SUMMER 1999. (AGATES WERE
POLISHED BEFORE BEING SKETCHED).

MOLE CRAB

Glass Bottles

Old glass jars and bottles provide an excellent glimpse into the past and are very collectable. I found four of these bottles, and discovered the fifth one in an antique shop. The glass objects sketched on this journal page are depicted using a variety of styles and mediums.

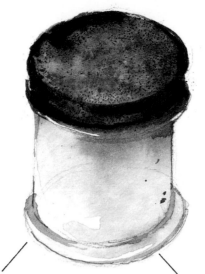

STOPPED WITH CORK

AMETHIST GLASS MEDICINE BOTTLE. FOUND AT NICE HOME-STEAD, NORTHPOWDER OR. – 1979.

GLASS STOPPER TOP

MUSTEROLE JAR FROM HOMESTEAD DUMP SITE. (LID RUSTED CLOSED). FOUND 1998.

OPAQUE MILK GLASS

GLASS TURNED OPALESCENT

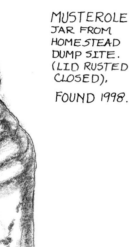

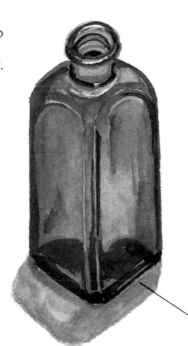

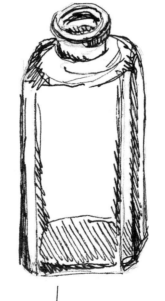

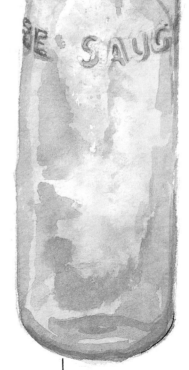

CLEAR BOTTLE FOUND AT AN EARLY HOMESTEAD SITE ON MT. HOOD, OR., WHERE A SEASONAL CREEK HAD WASHED OUT AN OLD DUMP.

FOUND - SUMMER OF 1998.

OLD COBALT MEDICINE BOTTLE FOUND IN MY GRANDMA'S CUPBOARD AS A CHILD AND KEPT BECAUSE IT WAS PRETTY. (THE BEGINNING OF MY COLLECTION).

LEA & PERRINS ON BACK IN RAISED LETTERS.

Fossil Hunting

Not being an archaeologist, but curious to see what ancient treasures the earth would yield to me, I visited the Stonerose Interpretive center in Washington state. At this site the public is lent tools and encouraged to dig their own fossils. The staff then identifies whatever you find. What fun! I also found some fossilized shells while walking along an Oregon beach. I recorded the best of my discoveries on this page.

Caution, check local and national laws before you excavate or gather relics, many sites and their contents are protected.

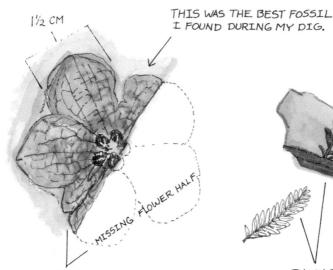

1½ CM

THIS WAS THE BEST FOSSIL I FOUND DURING MY DIG.

MISSING FLOWER HALF

FOSSIL FLOWER
FLORISSANTIA QUILCHENENSIS
(SHOWN LARGER THAN ACTUAL SIZE)

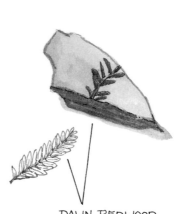

DAWN REDWOOD
METASEQUOIA
(SHOWN ACTUAL SIZE)

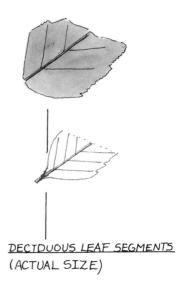

DECIDUOUS LEAF SEGMENTS
(ACTUAL SIZE)

ABOVE FOSSILS WERE FOUND AT STONEROSE INTERPRETIVE CENTER DIG SITE – 1994
(FOSSILS FROM THIS SITE BELIEVED TO BE 50 MILLION YEARS OLD).

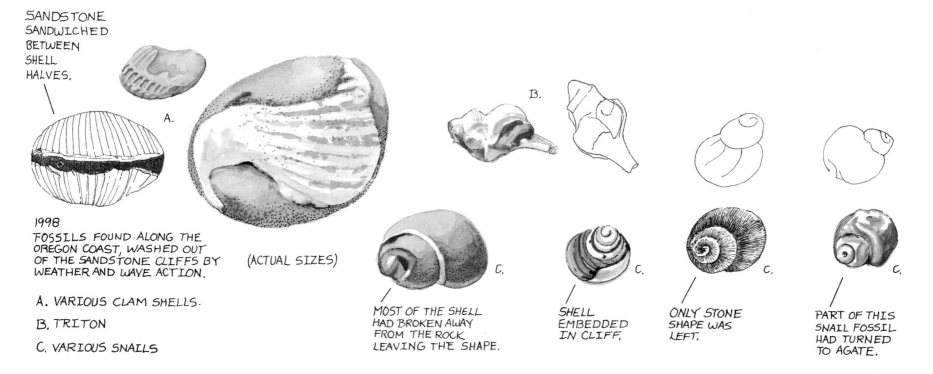

SANDSTONE SANDWICHED BETWEEN SHELL HALVES.

A.

B.

1998
FOSSILS FOUND ALONG THE OREGON COAST, WASHED OUT OF THE SANDSTONE CLIFFS BY WEATHER AND WAVE ACTION.

(ACTUAL SIZES)

A. VARIOUS CLAM SHELLS.

B. TRITON

C. VARIOUS SNAILS

MOST OF THE SHELL HAD BROKEN AWAY FROM THE ROCK LEAVING THE SHAPE.

C.

SHELL EMBEDDED IN CLIFF.

C.

ONLY STONE SHAPE WAS LEFT.

C.

PART OF THIS SNAIL FOSSIL HAD TURNED TO AGATE.

C.

Extraordinary Occurrences

Sometimes personal discoveries take the form of being witness to unexplained events or spectacular natural phenomena. Should you happen to sight Big Foot, The Loch Ness monster or a genuine U.F.O., notes and a journal sketch may be all the evidence you'll have to remember the occurrences. Here are some extraordinary events which impressed me.

Texturing technique used: salt sprinkled into a wet wash. (watercolor paper)

ASH FALL

DURING THE EVENING FOLLOWING THE ERUPTION OF MT. ST. HELENS, ASH FELL FROM THE SKY, COVERING OUR LAWN. IT LOOKED LIKE SNOW FALL, BUT WAS A DIRTY GRAY-BROWN. IT STAYED MANY DAYS UNTIL THE WIND BLEW IT AWAY. IT WAS VERY FINE AND CLOGGED THE AIR FILTER ON THE CAR. WE WORE FILTER MASKS WHEN WE WENT OUTSIDE.

MAY 18, 1980, ERUPTION OF M..!S . HELENS (WASHINGTON STATE)

I WITNESSED IT AS I DROVE TO CHURCH THAT SUNDAY MORNING.

THE ASH SPEWED FORTH LIKE ANGRY, BILLOWING CLOUDS OF SOOT. THE SNOWY PEAK WAS DIRTY GRAY.

NORTHERN LIGHTS

SEEN IN DELTA JUNCTION ALASKA - MARCH 1988

IT WAS PAST MIDNIGHT. I WAS IN A SNOW COVERED FIELD, SURROUNDED BY FOREST. THE LIGHTS WERE WHITE AND UNDULATED ACROSS THE SKY IN AN EERIE, BEAUTIFUL DANCE. THE SKY SEEMED TO CRACKLE. I WAS ALONE AND AT AWE.

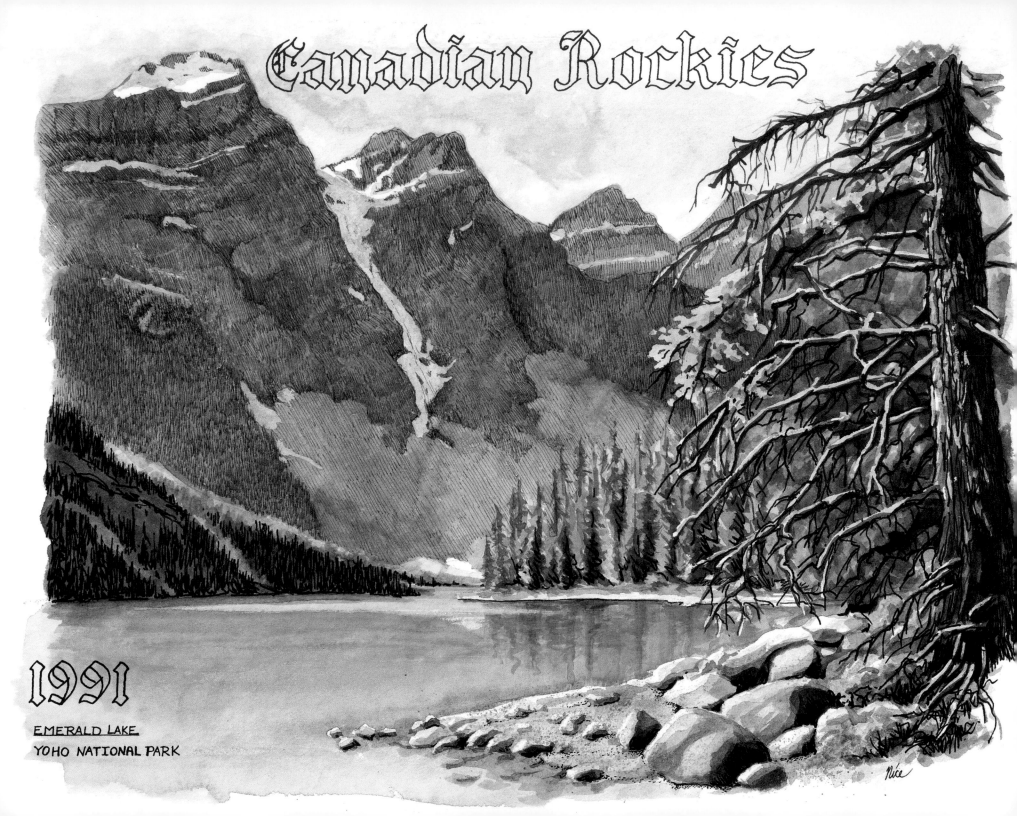

Canadian Rockies

1991

EMERALD LAKE
YOHO NATIONAL PARK

Chapter 7 — A Sketchbook of Travel Memories

You're ready to leave on a travel adventure, and you want to keep a record of your trip, so in an accessible pocket you've tucked your art tools and sketchbook journal. Somewhere amidst the confusion of the first or second day, you'll reach for it and begin.

Beginning is very important. If you procrastinate, it won't happen! Details grow fuzzy and enthusiasm fades quickly with the passing of time. Entries of events are most accurate and exciting if they are recorded as they happen. I carry a yellow lined note pad on which to jot notes as I go. If I'm traveling light, a couple of loose note papers and a pencil can easily be tucked into my pocket. I then transfer the notes and sketches to my journal later. This allows me the freedom to be a bit sloppy and haphazard when I'm in a hurry. Then I can organize my thoughts, correct misspellings and check references before entering them into the journal.

Working directly in your journal is not to be discouraged, however. Some really wonderful, spontaneous drawings and accidents occur that can be hard to transfer, such as fresh leaf prints, rain spatter or "just the right color" you mixed by accident. I carry liquid correction fluid to make changes to written mistakes if the correction won't be too noticeable or messy. It takes the fear out of writing on a page I've just spent considerable time illustrating.

Set aside time each day to work on your journal and keep it current. It's also important to keep your travel journal's contents factual and accurate. Glorifications and exaggerations belong in a fantasy journal or a travel brochure.

In this chapter I have included excerpts from my own vacation to the Canadian Rockies. As you will see, the narrative part of a travel journal tends to be longer and more complete than in some other journal types. If I were to improve upon it, I would include the dates as well as the days of the week. Keep in mind that almost everything that matters to you belongs in your journal—document it with accurate, detailed narrative and illustrations.

THINGS YOU MIGHT WANT TO INCLUDE IN YOUR TRAVEL JOURNAL ARE

accurate dates and times * weather observations * scenery descriptions * roads traveled (names and distances) * cities and villages passed through * accurate names and locations of attractions * descriptions of impressive sights * resources for information quoted (guidebooks, signs, park rangers) * descriptions of where you stay (hotels, inns, campgrounds) * interesting meals (where, when and what was eaten) * new experiences (riding animals, bungee jumping, mud baths) * wildlife descriptions * names and descriptions of interesting people encountered * cultural events and insights * local color and customs * interesting or humorous anecdotes * personal observations, thoughts and emotions * happy or inspiring occurrences * problems and frustrations encountered * foreign word interpretations * photos taken (photo number and what it is of)

BEADED HORSE BRIDLE - SEEN AT THE NEZ PERCE' MUSEUM.

MUCH OF THE SEED BEADS WERE SEWN IN ROWS ONTO FADED RED TRADE CLOTH. DESIGNS ARE GEOMETRIC. THE LARGE FACE PIECE IS KEY SHAPED AND TRIMMED IN TUFTS OF DYED HORSE HAIR. THE FACE PIECE TIES ONTO THE CROWN WITH A LEATHER THONG. (THE CHEEK PIECES TIED TO THE RINGS OF THE BIT.) COMPLEMENTARY COLORS WERE OFTEN PLACED SIDE BY SIDE.

FACE PIECE

HORSE HAIR

RED TRADE CLOTH PART OF DESIGN.

— BIT RING

FRIDAY— WE (MY HUSBAND JIM AND I) LEFT HOME IN THE EARLY EVENING HEADED DOWN I84, TRAVELING EAST IN OUR MOTOR HOME. WE MADE IT AS FAR AS BOARDMAN, OR.. THAT FIRST NIGHT WE SPENT IN A REST STOP, PARKED NEXT TO A SEMI REFRIGERATOR TRUCK. IT WAS VERY NOISY! WE WERE TIRED AND SLEPT ANYWAY.

SATURDAY— THE WEATHER WAS CLEAR AND WARM. THE LAND IN THE COLUMBIA RIVER PLATEAU IS FLAT, BROWN AND BARREN EXCEPT FOR THE ROUND PATCHES OF IRRIGATED POTATOES. WE DROVE EAST TO PENDLETON, THEN CROSSED INTO WASHINGTON STATE AT WALLA WALLA. WE REACHED LEWISTON, IDAHO IN THE AFTERNOON, STOPPING FOR THE NIGHT AT A MOTOR HOME PARK ON THE SNAKE RIVER. THE COUNTRY HERE IS DRY, WITH ROLLING HILLS. THE SNAKE RIVER REMINDS ME OF A BLUE-GRAY SATIN RIBBON CAST AMONGST THE PEBBLES ON SUN BAKED SOIL. THERE ARE LOTS OF VOLCANIC ROCKS IN THE CAMP GROUND. THE GROUND SQUIRRELS SCAMPER OVER THEM AND CHAISE EACH OTHER ABOUT.

WE STAYED IN THE LEWISTON AREA UNTIL MONDAY, RELAXING, WATCHING THE RIVER AND VISITING THE LOCAL TOURIST ATTRACTIONS, MY FAVORITE WAS THE NEZ PERCE' CULTURAL MUSEUM IN SPALDING. THEY HAD A WONDERFUL DISPLAY OF ARTIFACTS AND OLD HAND-WORKED CRAFTS. THE CLOTHING, BEADWORK AND WOVEN CORN HUSK BAGS WERE INTRICATE, COLORFUL AND STUNNINGLY BEAUTIFUL. I WANTED TO SKETCH THEM ALL IN MY JOURNAL AND HAD A HARD TIME LEAVING.

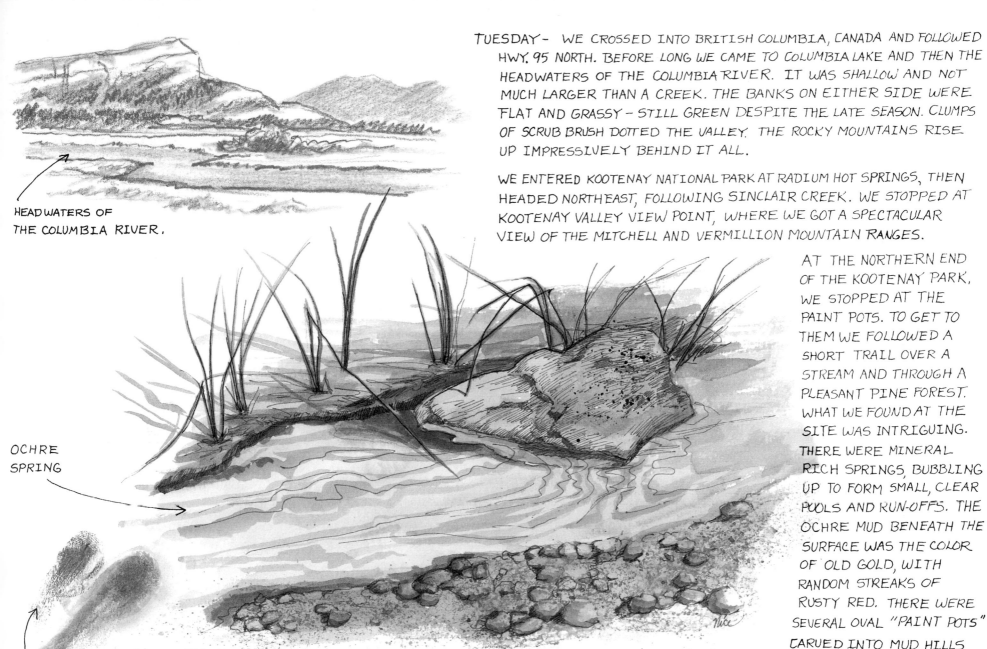

TUESDAY – WE CROSSED INTO BRITISH COLUMBIA, CANADA AND FOLLOWED HWY. 95 NORTH. BEFORE LONG WE CAME TO COLUMBIA LAKE AND THEN THE HEADWATERS OF THE COLUMBIA RIVER. IT WAS SHALLOW AND NOT MUCH LARGER THAN A CREEK. THE BANKS ON EITHER SIDE WERE FLAT AND GRASSY – STILL GREEN DESPITE THE LATE SEASON. CLUMPS OF SCRUB BRUSH DOTTED THE VALLEY. THE ROCKY MOUNTAINS RISE UP IMPRESSIVELY BEHIND IT ALL.

WE ENTERED KOOTENAY NATIONAL PARK AT RADIUM HOT SPRINGS, THEN HEADED NORTHEAST, FOLLOWING SINCLAIR CREEK. WE STOPPED AT KOOTENAY VALLEY VIEW POINT, WHERE WE GOT A SPECTACULAR VIEW OF THE MITCHELL AND VERMILLION MOUNTAIN RANGES.

HEADWATERS OF THE COLUMBIA RIVER.

OCHRE SPRING

I DIPPED MY FINGERS IN THE OCHRE MUD AND SMEARED IT ACROSS THE PAPER. RICH COLOR!

AT THE NORTHERN END OF THE KOOTENAY PARK, WE STOPPED AT THE PAINT POTS. TO GET TO THEM WE FOLLOWED A SHORT TRAIL OVER A STREAM AND THROUGH A PLEASANT PINE FOREST. WHAT WE FOUND AT THE SITE WAS INTRIGUING. THERE WERE MINERAL RICH SPRINGS, BUBBLING UP TO FORM SMALL, CLEAR POOLS AND RUN-OFFS. THE OCHRE MUD BENEATH THE SURFACE WAS THE COLOR OF OLD GOLD, WITH RANDOM STREAKS OF RUSTY RED. THERE WERE SEVERAL OVAL "PAINT POTS" CARVED INTO MUD HILLS WHERE, ACCORDING TO THE INTERPRETIVE SIGNS, NATIVE AMERICANS GATHERED PIGMENT AND MIXED IT WITH ANIMAL FAT TO MAKE PAINT. LATER, OCHRE PIGMENT WAS MINED COMMERCIALLY IN THE AREA. THE GOOEY YELLOW MUD MADE A GREAT TRACK TRAP. I SAW TRACKS MADE BY DEER, ELK, MOOSE AND COYOTES...... AND LOTS OF LITTLE PEOPLE FEET. BY THE LOOKS OF IT, SQUISHY OCHRE MUD IS ESPECIALLY IRRESISTABLE TO CHILDREN.

89

TUESDAY AFTERNOON WE CROSSED OVER THE SUMMIT OF VERMILLION PASS AND ENTERED BANFF NATIONAL PARK. THE MOUNTAIAN PEAKS ARE ALL AROUND US NOW AND THE AIR IS FRESH, COOL AND SWEET WITH THE SMELL OF PINE. THE WEATHER IS CLEAR.

WE PLANNED TO STAY IN ONE OF THE PARK CAMP GROUNDS, BUT THERE WAS SOME KIND OF STRIKE GOING ON AND THEY WERE CLOSED. WE FOUND OURSELVES CAMPED IN A WILDERNESS "OVERFLOW CAMPSITE" WHICH WAS A BIG GRAVEL PARKING LOT. IT WAS CROWDED WITH LOTS OF OTHER VACATIONERS. TO GET AWAY FROM THE NOISE AND CONFUSION OF SO MANY CAMPERS, WE WANDERED DOWN AN OLD GRAVEL ROAD AT SUNSET AND STARTED BACK IN THE DARK, WITH ONLY A FLASHLIGHT TO GUIDE US. IT WAS PEACEFUL UNTIL WE BEGAN TO HEAR SNORTS ALL AROUND US AND REALIZED WE WERE IN THE MIDDLE OF A NERVOUS ELK HERD. WE WERE NERVOUS TOO, AND GLAD TO REACH THE SAFETY OF THE CAMP.

WEDNESDAY MORNING – AS WE DROVE TOWARDS THE TOWN OF BANFF, THE ROAD CROSSED THROUGH A HIGH MOUNTAIN MEADOW. THE SUN WAS JUST RISING BEHIND THE MOUNTAIN PEAK AND MIST WAS RISING OFF THE FROSTY GRASS IN GHOSTLY WHISPS. THERE WAS A HERD OF ELK FRAMED AGAINST THE SKY-LINE. TWO BULL ELK, ON OPPOSITE SIDES OF THE MEADOW, CHALLENGED EACH OTHER IN ECHOING BUGLE CALLS. WE PULLED OFF THE ROAD AND WATCHED. IT WAS AN UNFORGETABLE SIGHT!

ELK IN THE MOUNTAIN MEADOW.

CALF

ELK COWS IN THE BOW RIVER

ANGRY BULL ELK (RUTTING SEASON)

WE RAN INTO MORE ELK IN THE BANFF TOWN PARK. A LARGE SIX POINT BULL HAD DRIVEN HIS COWS AND CALVES INTO THE BOW RIVER AND WAS PATROLING BACK AND FORTH ALONG THE BANK TO PROTECT THEM FROM A BUS LOAD OF JAPANESE TOURISTS. ONE MAN GOT TOO CLOSE WHILE ENGROSSED IN PICTURE TAKING AND WAS CHASED AND ALMOST CAUGHT BY THE ANGRY BULL ELK. THE HERD STAYED IN THE WATER SO LONG THAT ONE OF THE CALVES ACTUALLY NURSED, HIS CHEST SUBMERGED AND HIS CREAMY RUMP IN THE AIR.

HEADING NORTHWEST, WE REACHED LAKE LOUISE LATER WEDNESDAY MORNING. THE LAKE IS A BLUE-GREEN COLOR, WITH THE ICE AND STONE OF THE TOWERING PEAKS REFLECTED MIRRORLIKE IN ITS STILL WATERS. THERE ARE LOTS OF TOURISTS WALKING THE PAVED PATHS ALONG THE SHORE, AND CANOES SKIM ACROSS THE WATER CREATING SILVERY RIPPLES. CHIPMUNKS AND JAYS TAKE ADVANTAGE OF TOURIST GENEROUSITY TO FATTEN UP FOR WINTER. IT'S A BUSY PLACE!

A SHORT DRIVE SOUTH BRINGS US TO MORAINE LAKE. IT'S EVEN MORE SPECTACULAR IN HUE THAN LAKE LOUISE, THE WATER'S A BRILLIANT THALO TURQUOISE. IT REMINDS ME OF AN AQUAMARINE GEM STONE SET IN A CONIFER BAND OF JADE GREEN. MORAINE LAKE BECOMES OUR LUNCH SPOT AND WE SIT AND PONDER ITS BEAUTY.

AFTER LUNCH JIM RIDES THE LAKE LOUISE GONDOLA TO GET EVEN LOFTIER VIEWS OF THE SCENERY. I STAY BEHIND TO FINISH SOME SKETCHES. (I DON'T LIKE TO DANGLE FROM WIRES IN THE SKY.)

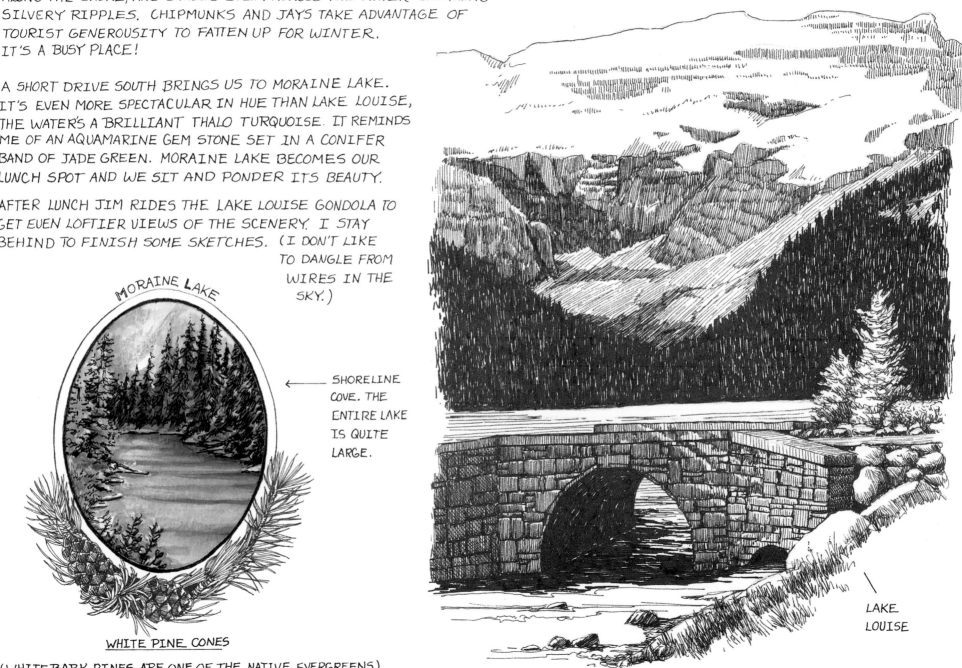

MORAINE LAKE

← SHORELINE COVE. THE ENTIRE LAKE IS QUITE LARGE.

WHITE PINE CONES

(WHITE BARK PINES ARE ONE OF THE NATIVE EVERGREENS).

LAKE LOUISE

91

WEDNESDAY LATE AFTERNOON — TRYING TO CRAM ONE MORE SIGHT INTO A BUSY DAY, WE HEADED NORTH ON THE ICEFIELDS PARKWAY. WE DROVE AS FAR AS BOW SUMMIT—(2088 M. ACCORDING TO THE ROAD SIGN). THE VIEW WAS WELL WORTH IT. WE WERE ABOVE TIMBERLINE AND THE ALPINE MEADOWS STILL HAD A FEW BLOSSOMS. FROM THE VIEWPOINT WE LOOKED DOWN ON THE ROBIN-EGG-BLUE WATERS OF PEYTO LAKE AND ACROSS TO THE DISTANT GLACIERS. I WOULD HAVE LIKED TO HAVE GOTTEN CLOSER TO THE ICEFIELDS··· PERHAPS EVEN TAKEN ONE OF THE SNOW CAT TOURS OUT ON THE ICE. (A GOOD EXCUSE FOR A RETURN IN THE FUTURE).

THE SUN WAS LOW AND WE STILL HAD TO FIND A CAMPSITE FOR THE NIGHT, SO WE STARTED BACK THE WAY WE CAME.

PEYTO LAKE

COLUMBIA ICEFIELD

WE FOUND A CAMPGROUND ON THE RIVER, COOKED DINNER AND SAT DOWN FOR A RELAXING MEAL AT THE PICNIC TABLE. WE DIDN'T KNOW THE SITE INCLUDED DINNER GUESTS. STELLER JAYS! BEFORE WE COULD PUT OUR FORKS TO OUR MOUTHS, THEY STARTED ARRIVING, DIVING AND FLAPPING ABOUT, THEIR RAUCOUS CRIES ENCOURAGING ONE ANOTHER ON TO GREATER MISCHIEF. IN THEIR BLACK HOODED MASKS, THEY REMINDED ME OF A BAND OF MERRY ROBBERS. PERHAPS STEALING JAY WOULD HAVE BEEN A MORE APPROPRIATE NAME. THEY ARE BEAUTIFUL BIRDS AND I MUST ADMIT I ENJOYED THEIR ANTICS. THEY FINALLY LEFT, THEIR ROYAL BLUE TUMMIES WELL STUFFED WITH CRUMBS FROM OUR TABLE.

STELLER'S JAY, WITH A BEAK FULL OF BREAD.

THURSDAY — WE DROVE THROUGH YOHQ NATIONAL PARK ON HIGHWAY 1A, HEADED IN THE DIRECTION OF HOME. THE GREAT DIVIDE WAS AN INTERESTING STOP, WHERE THE WATERS OF DIVIDE CREEK FLOW BOTH EAST AND WEST. WE ALSO PULLED OVER TO WATCH A FREIGHT TRAIN WIND ITS WAY THROUGH THE SPIRAL TUNNEL.

LEAVING THE MAIN HIGHWAY BRIEFLY, WE DROVE TO THE MOST BEAUTIFUL BODY OF WATER I'VE EVER SEEN — EMERALD LAKE. THE VIVID AQUA, TURQUOISE AND EMERALD COLORATION WAS ALMOST UNBELIEVABLE. (IT'S ILLUSTRATED ON THE TITLE PAGE). THIS WAS ALMOST OUR LAST SIGHT. THE EMERALD LAKE ROAD IS TWO LANE, AND NARROW AND WINDY IN PLACES. VERY SCENIC. A SPEEDING TOURIST BUS CUT WIDE COMING AROUND A BLIND CURVE AND NEARLY FORCED US OVER A CLIFF. TWO OF THE MOTORHOME'S DUEL WHEELS WERE ACTUALLY HANGING OVER THE EDGE AS WE MADE THE BEND. WHEW!

AFTER THAT EXCITEMENT WE STOPPED ALONG THE KICKING HORSE RIVER TO STRETCH OUR LEGS AND ADMIRE THE FANTASTIC ROCK FORMATIONS. THE WATER HAD ERODED THE STONE INTO NATURAL BRIDGES, ARCHES AND FLAT TOP OVERHANGS. JIM AND I COULD'NT RESIST CLIMBING OVER THEM TO TAKE PHOTOS AND MAKE SKETCHES. THE CONTRAST OF STONE AND WATER WAS TRULY AN ARTIST'S DELIGHT.

NATURAL BRIDGE AND WATER PASSAGE — KICKING HORSE RIVER.

JIM WITH HIS CAMERA, WALKING OVER THE WORN ROCKS OF KICKING HORSE RIVER.

93

Color Study — Jar & Pears

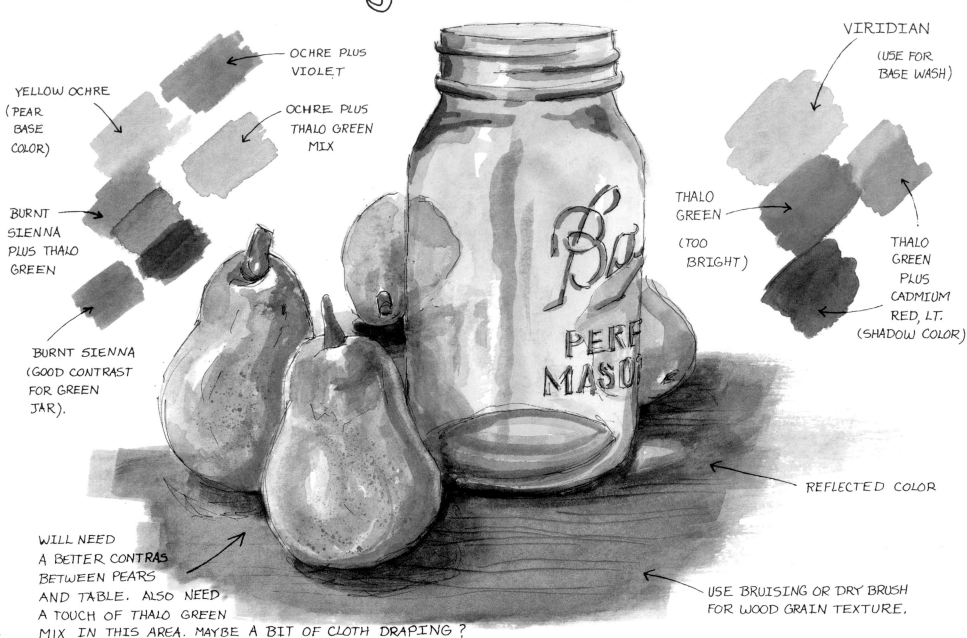

OCHRE PLUS VIOLET

YELLOW OCHRE (PEAR BASE COLOR)

OCHRE PLUS THALO GREEN MIX

VIRIDIAN (USE FOR BASE WASH)

BURNT SIENNA PLUS THALO GREEN

THALO GREEN (TOO BRIGHT)

BURNT SIENNA (GOOD CONTRAST FOR GREEN JAR).

THALO GREEN PLUS CADMIUM RED, LT. (SHADOW COLOR)

REFLECTED COLOR

WILL NEED A BETTER CONTRAS BETWEEN PEARS AND TABLE. ALSO NEED A TOUCH OF THALO GREEN MIX IN THIS AREA. MAYBE A BIT OF CLOTH DRAPING ?

USE BRUISING OR DRY BRUSH FOR WOOD GRAIN TEXTURE.

Chapter 8 — An Illustrated Reference Journal

The reference journal is the workhorse of all journals. It is here that the artist, collector, inventor, student, teacher or whomever stores notes on random bits of interest or serious ongoing projects. It is an illustrated collection of information that does not necessarily need to be organized, often haphazard and spontaneous in appearance. The artwork may be precise, but most often is quickly rendered in simple lines and scribble strokes. The handwriting may be the creator's worst scrawl; the ideas often come faster than the pen can move. Here, for the sake of legibility, I have continued to use the same printed journal notes seen in other chapters.

The reference journal is meant to be close at hand, ever ready to record the inspirations, ideas, observations and inspiring insights beheld by its keeper. It is usually small enough to fit in a pocket or purse if the record keeper is active, or may be larger and stored at a frequent-ly used location, such as a studio, laboratory, office or work station. Like a life diary, the reference journal may contain fragments of the author's day-to-day experiences, thoughts and encounters, but because of its cluttered, somewhat eclectic nature, it is less likely to have meaning to others. The exception is the well-kept record that itemizes a collection or explains a project.

What should be included in your personal reference journal? Record anything that is of interest to you now, or could possibly be of interest to you in the future, including enough artwork to adequately recall it to mind. If it catches your eye or tweaks your mind, include it!

The example to the left shows a color study one might find in an artist's reference journal. The quick study allows the artist to see how colors actually work together in a composition before using them in a painting.

Art Applications

The reference journal provides a work space for the artist to explore shapes, color, value, texture and compositional arrangements before committing his efforts to a more permanent and time consuming art piece. Thumbnail sketches can show the artist a multitude of pitfalls that can be avoided.

Here are some hasty, experimental sketches of a cabin I visited in the Smoky Mountains. Two of them could be developed into good paintings.

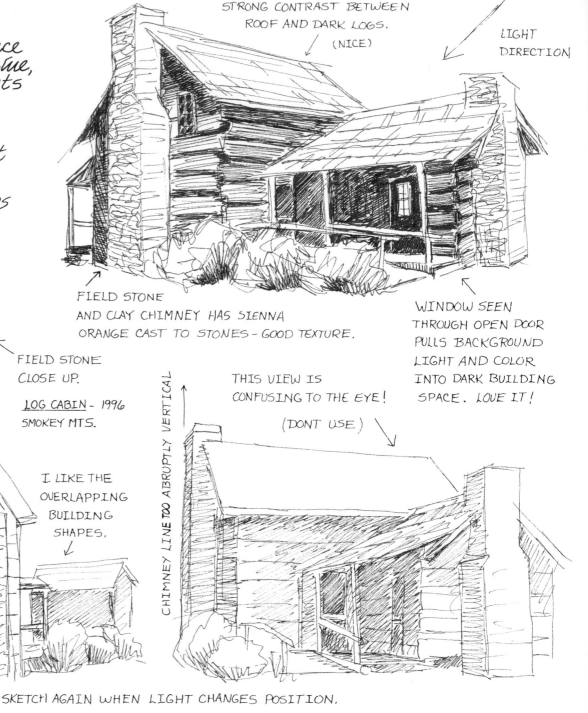

STRONG CONTRAST BETWEEN ROOF AND DARK LOGS. (NICE)

LIGHT DIRECTION

FIELD STONE AND CLAY CHIMNEY HAS SIENNA ORANGE CAST TO STONES - GOOD TEXTURE.

WINDOW SEEN THROUGH OPEN DOOR PULLS BACKGROUND LIGHT AND COLOR INTO DARK BUILDING SPACE. LOVE IT!

FIELD STONE CLOSE UP.

LOG CABIN - 1996 SMOKEY MTS.

THIS FRONT DOOR VIEW MAKES A GOOD COMPOSITION SHAPE-WISE, BUT BACK-LIGHTING PROVIDES LITTLE CONTRAST ON THE WHOLE FRONT SIDE OF CABIN

I LIKE THE OVERLAPPING BUILDING SHAPES.

CHIMNEY LINE TOO ABRUPTLY VERTICAL

THIS VIEW IS CONFUSING TO THE EYE!

(DONT USE)

SKETCH AGAIN WHEN LIGHT CHANGES POSITION.

The eye of an artist comes across lots of intriguing possibilities in day to day life, ranging from terrific subject matter and interesting background material to simple colors, lines and shapes that beg to be recorded. One never knows when such things will be useful. Here are some sketches and notations from my reference pages.

RECTANGLAR, FLAT BOAT SKETCHED AT COMPASS LAKE, FL. - 1996 (RESTING ON DRY SAND, NO REFLECTION).

STRAIGHT ACROSS

V SHAPED

DUCKS

GEESE

STUDIES OF DUCK AND GEESE FACES

BILL NARROWER THAN GOOSE BEAK

TREE ROOT SYSTEM STICKING OUT OF SNOW BANK - JUNE 1994.

HURRICANE RIDGE, WN.

MIGHT MAKE A GOOD FOREGROUND STUDY IN A BEACH SCENE OR WOODSY LANDSCAPE.

FISHING BOAT RESTING ON WET SAND.

OR 133·LM

REFLECTION

CAPE KAWANDA, OR.

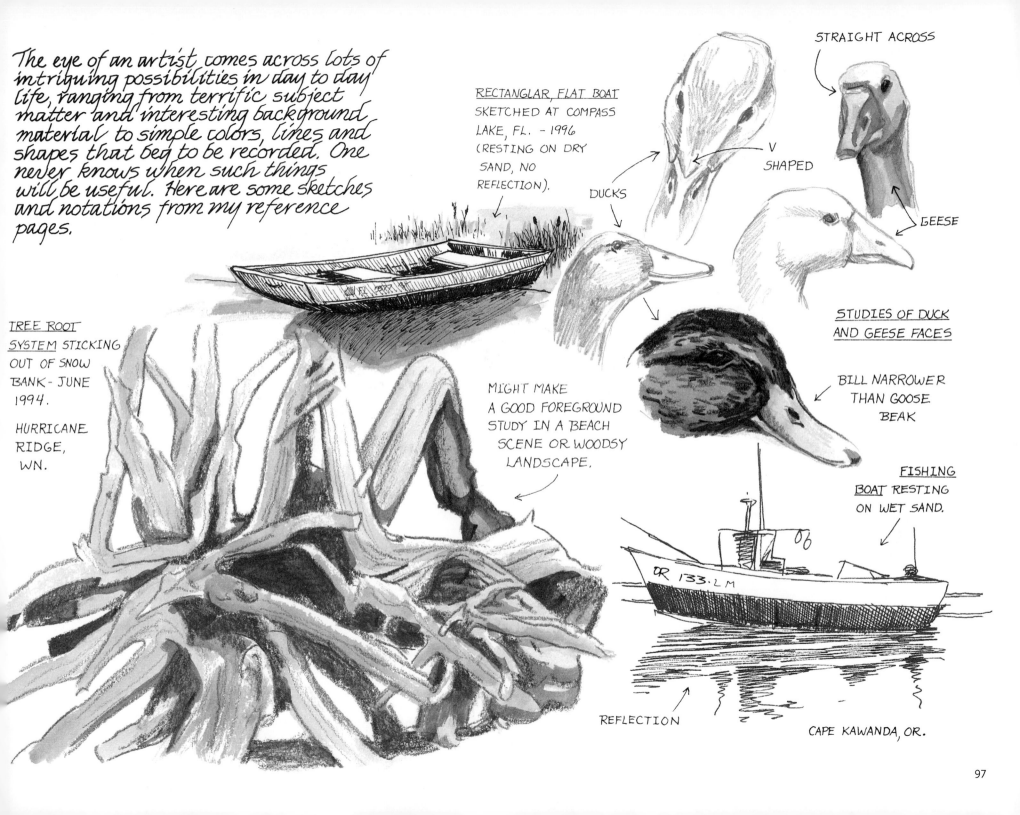

Birding Lists

When a reference journal accompanies the birder into the field, new finds and old friends can be documented as they appear. Notes are more accurate if taken on the spot and _simple_ illustrations will verify what was actually seen. If desired, both notes and drawings can be transfered to a more finished, detailed journal at the birder's leisure.

On this page I've used basic egg and oval shapes to rough in the birds that visited my feeding station during a one hour period. Quick washes of color brought them to life. (The browns and grays found mixed on a previously used, dirty watercolor palette are great for this).

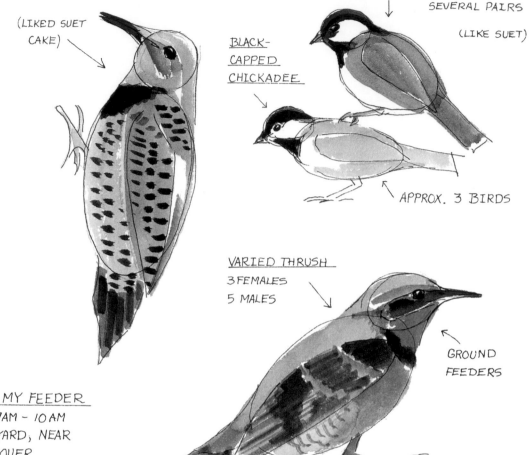

RED SHAFTED FLICKER – 1 MALE

(LIKED SUET CAKE)

CHESTNUT-BACKED CHICKADEE

SEVERAL PAIRS

(LIKE SUET)

BLACK-CAPPED CHICKADEE

APPROX. 3 BIRDS

VARIED THRUSH
3 FEMALES
5 MALES

GROUND FEEDERS

BIRDS SEEN AT MY FEEDER
JAN. 28, 2000 9AM – 10AM
LOCATED IN SIDEYARD, NEAR
HEAVY CONIFER COVER.
BRIGHTWOOD VALLEY,
MT. HOOD, OR.

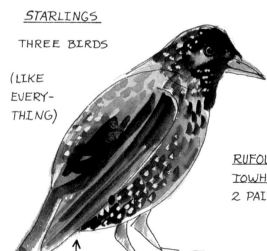

STARLINGS

THREE BIRDS

(LIKE EVERY-THING)

White markings added with Liquid Paper correction fluid.

RUFOUS-SIDED TOWHEE
2 PAIRS

GROUND FEEDER

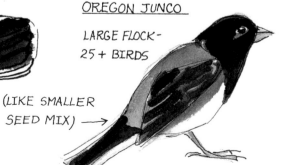

OREGON JUNCO

LARGE FLOCK-
25 + BIRDS

(LIKE SMALLER SEED MIX)

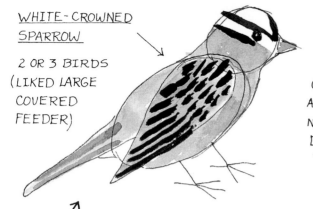

WHITE-CROWNED SPARROW

2 OR 3 BIRDS
(LIKED LARGE COVERED FEEDER)

NOTE:
A LARGE FLOCK OF CROWS PERCHED AND CALLED IN THE NEAR BY TREES BUT DID NOT COME TO THE FEEDER TODAY.

Drawn by my art challenged husband, Jim, at my request, to prove anyone can sketch using simple shapes. Not bad!

RED-WINGED BLACKBIRD

3 PAIRS
(LIKED SMALL HANGING SEED FEEDER)

STELLER'S JAY

8 - 10 BIRDS

(LIKE ALL THE FEEDERS. LOVE SUNFLOWER SEEDS AND BREAD).

(RASCALS, BUT BEAUTIFUL)

Collections

I am fascinated by old glass trade beads and have an on-going collection of them. To help me remember the story behind each bead, where I got it and its value, I maintain a small reference catalog. It's an added bit of enjoyment to sketch each new bead into this journal, all the while pondering who might have worn it in the past. When this collection is passed down to my children or grandchildren, the reference entries will make it so much more meaningful for them!

Note: The stated values of collected items recorded in a reference journal should be updated periodically as they appreciate.

5/8" WIDE

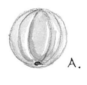

A.

9/16"
B.

3/8"
B.

1/2" LONG

C.

(A) SEMI CLEAR, MELON SHAPED. PURCHASED IN A FLEA MARKET IN NEW JERSEY. (1988) COST $8.00 PROBABLY BOHEMIAN – 1600 - 1700s.

(B) 6 COBALT 5 SIDED BEADS. WOUND AND PRESSED GLASS. PURCHASED IN WEST COAST ANTIQUE SHOP – $7.50 ea. DUTCH - LATE 1600 S (1990 - OFFERED $25.00 ea.)

(C) CORNALINE D' ALEPPO – WOUND TRANSPARENT (BRICK) GLASS OVER OPAQUE YELLOW CENTER. 2 BEADS AT $5.00 ea. PURCHASED 1989 FROM BAKER BAY BEAD CO. VENETIAN - LATE 1700 S (USED TO TRADE FOR BEAVER PELTS)

Plans and Concepts

One needs little imagination to see how important an illustrated reference journal could be to a craftsman, an inventor or professional creator like an engineer or architect. In order for ideas to become reality, they usually have to be set down on paper and worked out. The reference journal is the place to begin.

Here are some preliminary plans I worked out for a rustic stick chair held together with knot and cord lashing. It did become reality, is useable and sits on the front porch of my mountain home.

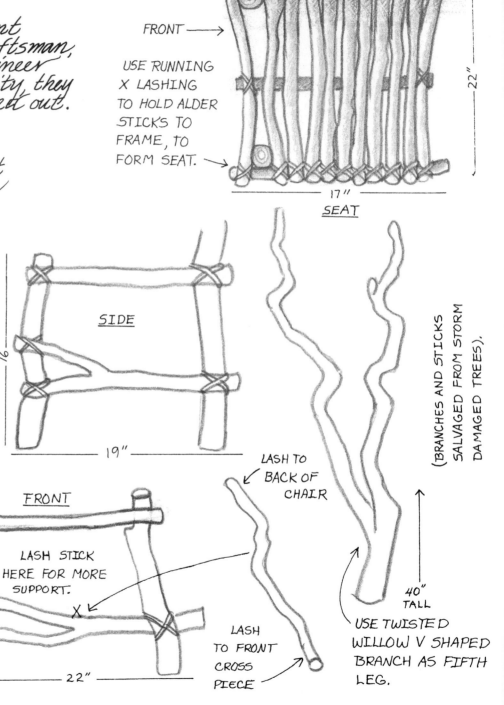

FRONT →

USE RUNNING X LASHING TO HOLD ALDER STICKS TO FRAME, TO FORM SEAT. →

22"

17"

SEAT

SIDE

16"

19"

(BRANCHES AND STICKS SALVAGED FROM STORM DAMAGED TREES).

LASH TO BACK OF CHAIR

40" TALL

USE TWISTED WILLOW V SHAPED BRANCH AS FIFTH LEG.

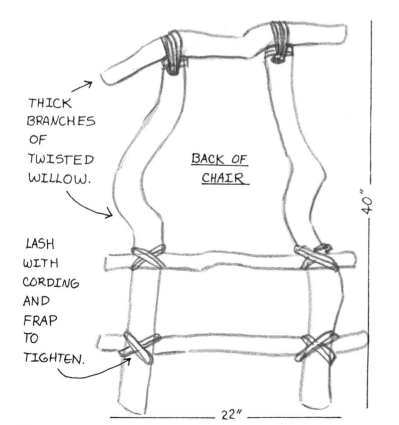

THICK BRANCHES OF TWISTED WILLOW.

BACK OF CHAIR

40"

LASH WITH CORDING AND FRAP TO TIGHTEN.

22"

FRONT

16"

LASH STICK HERE FOR MORE SUPPORT.

X

LASH TO FRONT CROSS PIECE

22"

12 HOURS CONSTRUCTION TIME.

THIS IS HOW THE 5 LEGGED, TWISTED WILLOW CHAIR TURNED OUT.

(IT MADE A WONDERFUL CONVERSATION PIECE AND IS NOT UNCOMFORTABLE TO SIT IN.)

HOLES WERE DRILLED IN BACK POSTS TO LASH THROUGH TO SECURE ON TOP CROSS PIECE.

NOTE: AFTER A YEAR OF USE, A FEW NAILS WERE ADDED TO TIGHTEN UP THE JOINTS. THE LASHED BINDINGS TENDED TO LOOSEN UP AND GET WOBBLY IN MOIST WEATHER.

FOUR STICKS WERE ADDED ACROSS THE BACK FOR MORE SUPPORT AND COMFORT.

STICK RUNNING FROM FRONT CROSS PIECE OF CHAIR TO FIFTH LEG, **LOCKS** LEG IN POSITION.

BARK LEFT ON STICKS AND BRANCHES

FORKED, TWISTED BRANCHES USED AS CROSS BRACES FOR THE LEGS ADDED A WILD, TANGLED APPEARANCE.

NOT AS JUMBLED AS IT APPEARS IN DRAWING.

FIFTH LEG ADDS BOTH STABILITY AND INTEREST.

CHOLLA

CYLINDROPUNTIA SPINOSIOR
<u>CANE CHOLLA</u>

FRUIT

SPINES 8 - 18 PER
AREOLE (3/8 - 5/8 INCH LONG).
FRUIT IS YELLOW,
(1 - 1½ INCHES)

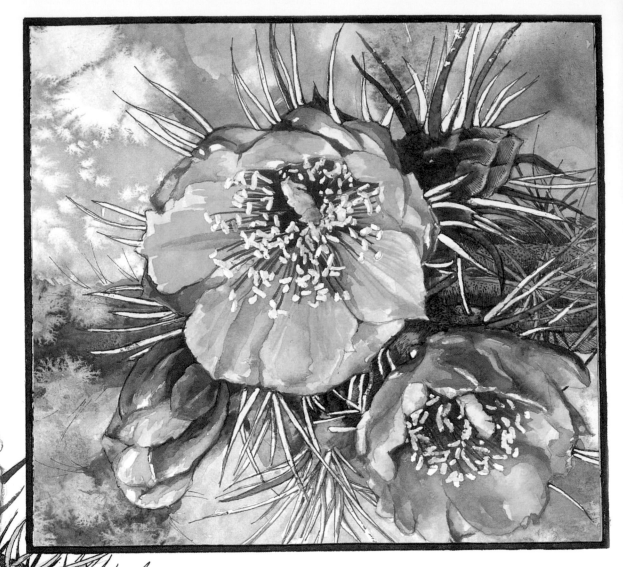

CANE CHOLLA STUDIES MADE FROM
SPECIMENS SEEN IN SOUTHERN
ARIZONA, MAY 1994.

PLANT WAS TREE-LIKE,
6 - 10 FEET TALL. BLOSSOMS
VARIED IN COLOR FROM
YELLOW TO MAROON.

BRANCHES VERY TUBERCLED.

Chapter 9 — An In-Depth Study Journal

The in-depth study journal is a place where subjects of special interest to the record keeper are explored in detail and with great completeness. It takes the discovery and reference journals a step further. Notes are precise, observations are thorough, illustrations are intricate and, in most cases, research is required. While the articulate nature of the in-depth study journal may not appeal to everyone, it is of great use to those with the spirit of inquiry who don't mind putting forth great effort to gain insight. Leonardo da Vinci was one such person. He had an unquenchable curiosity and maintained volumes of detailed notes and precise illustrations on subjects, including botany, zoology, anatomy and physical science, all aimed at making himself a better painter. The results are reflected in his work.

I have maintained three in-depth study journals through the years. The oldest is a study of wildflowers. Now and again I select a plant of special interest and spend several hours painting it with as much realism as I can muster. I study its roots, leaves, flowers, seeds and growing conditions to learn as much as I can about it. Then I look it up in a reference book to find its scientific name and history. If it's edible, I taste. And when I'm finished, I know that plant well! Excerpts from my wildflower journal are shown on the preceding and following pages.

The other two journals are offshoots of the first. One is a notebook of wild, edible berries, and the other contains native ferns of the Northwest. Each entry has a full-color, detailed illustration painted from life. Often more than one view is shown (see deer fern entry on page 105). I hope to someday find and record all the Northwestern ferns, but there's no hurry. I learned long ago that the fun is in the doing, and when I've finished one project, I'll just begin another. However, too many journal projects can be overwhelming. Sometimes it works well to add an in-depth study section to a journal that's already established. Remember that the purpose of the in-depth study journal is not just to create a book, but to gain knowledge. Proceed in a format that meets your needs.

SOME POPULAR SUBJECTS FOR THIS TYPE OF JOURNAL INCLUDE

trees ❋ wildflowers ❋ unusual plants ❋ fungi, mushrooms ❋ ferns, mosses ❋ seaweed ❋ wild animals ❋ birds, nests, eggs ❋ fish, sea creatures ❋ seashells ❋ reptiles, dinosaurs ❋ insects, butterflies ❋ native arts, crafts ❋ antiques, relics ❋ human anatomy ❋ facial expressions ❋ stars, constellations ❋ clouds, weather ❋ rock formations ❋ rocks, fossils ❋ musical instruments ❋ antique vehicles ❋ machinery, engines ❋ inventions ❋ architecture ❋ color theory ❋ knot-tying ❋ sports equipment

HIBISCUS

HYBRID—
HIBISCUS KOKIO (NATIVE HAWAIIAN STATE FLOWER) CROSSED WITH
HIBISCUS ROSA-SINENSIS (CHINESE RED HIBISCUS).

CLOSE-UP VIEW OF PISTIL

— 5 HEAD-LIKE STIGMAS

— STAMEN

— STYLE

— (ACTUAL SIZE)

PAINTED IN A
PRIVATE GARDEN
BELONGING TO
A NEIGHBOR.
WAIPAHU, OAHU,
HAWAII.

1974 ⟶

RED PETALS
STAIN PURPLE
WHEN CRUSHED. ⟶
(NOT USED FOR LEIS).

LEAVES SMOOTH
AND GLOSSY

WILTED FLOWER.
HIBISCUS BLOSSOMS
WILL USUALLY STAY
FRESH, WHEN PICKED
AND LEFT OUT OF WATER,
FOR ONE DAY.

nice

BUD— THE CALYX CONSISTS
OF FIVE LOBES,
SIMILAR TO THE
HOLLYHOCK.

B.

A.

C.

DEER FERN
BLECHNUM SPICANT

GROWS IN HEAVY TO MODERATE SHADE, IN MOIST AREAS. THESE SPECIMENS WERE SKETCHED ON WILDCAT MT., MT. HOOD FOREST LAND, OREGON.

RANGE - WESTERN CASCADES, SOUTH TO CALIFORNIA AND ALSO IN NORTHERN IDAHO. FOUND FROM SEA LEVEL TO MID-MOUNTAINS.

PINNAE

LEAF PRINT FROM A YOUNG PLANT

CLOSE-UP VIEW OF VEINS IN STERILE PINNAE

A. STERILE LEAF (FULL SIZE)
B. FERTILE LEAF (FULL SIZE). THESE ARE LOCATED IN THE CENTER OF THE PLANT AND ARE USUALLY TALLER THAN STERILE LEAVES. LEAFLETS (PINNAE) ARE NARROW.
C. CLOSE-UP VIEW OF FERTILE PINNAE WITH SPORE. AS THE PINNAE AGES THE EDGES CURL INWARD OVER THE SPORES.

REFERENCES USED: FLORA OF THE PACIFIC NORTHWEST- (HITCHCOCK AND CRONQUIST) PACIFIC COAST FERN FINDER - (KEATOR AND ATKINSON)

Wildlife Studies

Native birds and animals make great in-depth study subjects. In order to get them to hold still for detailed drawings, take photos or sketch from the stuffed specimens found at Audubon Societies, Natural History museums and interpretive exhibits.

COLOR STUDY ⟶

TAIL TIPPED WITH
WHITE HAIRS,
TURNING BLACK NEAR
THE BASE.

TOWNSEND'S CHIPMUNK
ENTAMIAS TOWNSENDII

SKETCHED SEPTEMBER 1999, AS
IT FED IN THE SEED FEEDER BEHIND
THE HOUSE, MT. HOOD CORRIDOR, OR.
NOTE THAT CHEEK POUCHES ARE STUFFED
AND BODY IS FAT, READY FOR HIBERNATION.

FRONT FOOT

TRACKS
IN MUD.

HIND FOOT

STUFFED
FOOD POUCH

APPROXIMATELY 9 INCHES FROM NOSE
TO TAIL TIP.

CHIPMUNK COLONY NESTING BETWEEN
LARGE STONES IN ROCK AND DIRT
RETAINING WALL, BEHIND THE HOUSE.
THEY ARE ACTIVE AND FEEDING FROM
BIRD FEEDER FROM APRIL TO OCTOBER.

FAVORITE FOODS: NUTS, SUNFLOWER SEEDS, SUET, BREAD, CORN, PEANUTS,
AND JUNK FOOD. THEY FEED ALONG SIDE THE SMALL
JUNCO-SIZED BIRDS.

VARIED THRUSH

(IXOREUS NAEVIUS)

STUDIES WERE SKETCHED FROM AN INJURED, UNCONSCIOUS BIRD FOUND IN OUR BACK YARD (Mt. HOOD CORRIDOR, OR.), JAN. 2000. INJURIES PROBABLY DUE TO FLYING INTO A WINDOW. ALTHOUGH KEPT WARM AND COMFORTABLE, BIRD DID NOT REGAIN CONSCIOUSNESS.

(MALE)
DRAWN ACTUAL SIZE

VARIED THRUSHES FREQUENT OUR BIRD FEEDING STATION WHERE THEY FEED MOST OFTEN ON THE GROUND. WHEN STARTLED, THEY FLEE INTO THE NEAR-BY CONIFER FOREST.

UNDER WING HAS TWO BANDS OF WHITE STRETCHING ACROSS IT.

LEADING EDGES OF PRIMARIES ARE RUFUS.

(WHITE TIPS ON OUTER TAIL FEATHERS)

ENLARGED VIEW OF BILL.

TINY FEATHERS ON EYE LIDS.

WHISKER-LIKE HAIRS EXTENDING ABOVE UPPER MANDIBLE.

BELLY WHITE

UNDER TAIL COVERT FEATHERS MOTTLED - DARK GRAY, WITH WHITE AND PALE RUFUS TIPS.

MANTLE

UPPER RIGHT WING SHOWING RUFUS COLOR PATTERN

SIDE

BREAST

CONTOUR BODY FEATHERS (EDGES SPLAYED APART - HAIR-LIKE)

LEADING EDGE

LEFT FOOT

CALLUS LUMP, NOT PRESENT ON RIGHT FOOT. INJURY?

PRIMARY FLIGHT FEATHER (LEFT WING).

BACK CLAW SPUR-LIKE.

SECONDARY FLIGHT FEATHERS

PRIMARY FLIGHT FEATHERS

Ⓐ

WING COVERTS (PRIMARY)

ALULA FEATHER

ENLARGEMENT OF A. (A TERTIAL FEATHER)

CENTER TAIL FEATHER - DARK GRAY (ACTUAL SIZE)

Collections can be greatly enhanced,
be they butterflies, stamps or thimbles,
if they're documented with precise
notes and drawings in a journal.

PALE TIGER SWALLOWTAIL

LIFE SIZE

(PTEROURUS EURYMEDON)

LORQUIN'S ADMIRAL

(BASILARCHIA LORQUINI) - LIFE SIZE

SKETCHED FROM SPECIMEN CAUGHT
ON ASTERS, IN YARD - SUMMER 1999
(VERY AGGRESSIVE)

CABBAGE WHITE

LIFE SIZE

(ARTOGEIA RAPAE)

SKETCHED FROM
GARDEN SPECIMEN
(LOVES NASTURTIUMS)

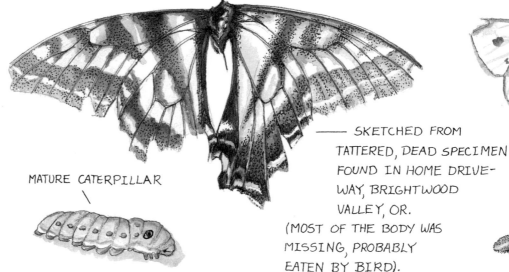

MATURE CATERPILLAR

——— SKETCHED FROM
TATTERED, DEAD SPECIMEN
FOUND IN HOME DRIVE-
WAY, BRIGHTWOOD
VALLEY, OR.
(MOST OF THE BODY WAS
MISSING, PROBABLY
EATEN BY BIRD).

IDENTIFICATION REFERENCE:
THE AUDUBON SOCIETY FIELD GUIDE TO NORTH AMERICAN BUTTERFLIES
PETERSON FIRST GUIDES - CATERPILLARS - WRIGHT

Architecture

For those who have a passion for old buildings, the in-depth sketchbook makes a splendid place to document them. Since the whole building must be drawn small to fit the space, enlargements can be included to bring special parts of the structure into focus.

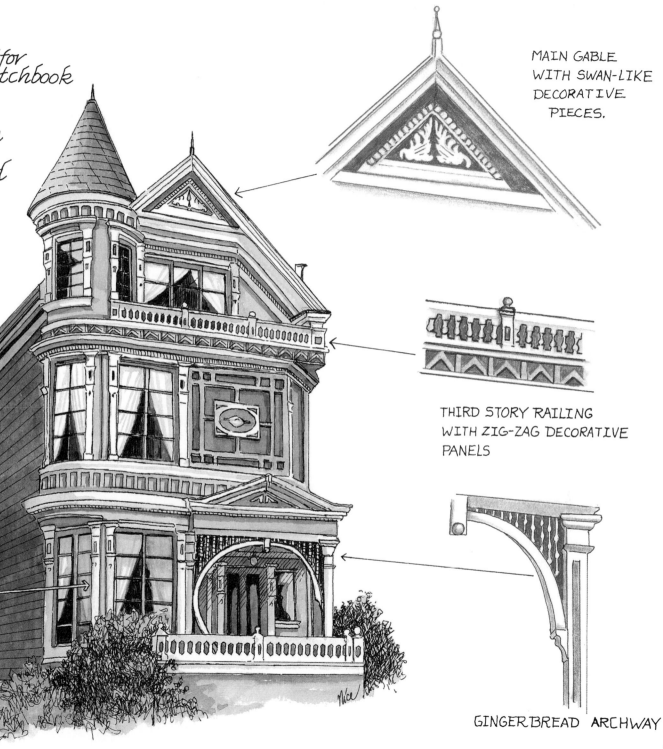

SAN FRANCISCO VICTORIAN
SKETCHED NOV. 1999

(UNIQUE PORCH ARCHWAY CAUGHT MY EYE).

CORNER PILLARS - MORE DECORATIVE THAN LOAD BEARING.

MAIN GABLE WITH SWAN-LIKE DECORATIVE PIECES.

THIRD STORY RAILING WITH ZIG-ZAG DECORATIVE PANELS

GINGERBREAD ARCHWAY

WEE FOLK of the HEMLOCKS

THE WEE ONES OF THE HEMLOCK TREES ARE THE WEAVERS OF THE FOREST. THE HE-SPRITES GATHER BITS OF COBWEB, COCOON SILK AND COTTONWOOD FLUFF, WHICH THE OLD ONES SPIN INTO GOSSAMER THREADS.

THE NIMBLE FINGERS OF THE YOUNG SHE-SPRITES WEAVE THE STRANDS INTO FABRIC SO DELICATE ONLY THE DAINTY FAERIE FOLK CAN USE IT. THE FEATHERY HEMLOCK BOUGHS SHIELD THE SPRITES FROM VIEW AND PROVIDE THE RUSTIC LOOMS.

WILLA—
GRAND WEAVER OF THE WESTERN HEMLOCK STAND.

Chapter 10 — A Sketchbook of the Imagination

Where does your mind go when it enters the realm of the imagination? Do you envision animals with human traits, fantastic alien creatures, magical kingdoms of dragons and sorcery, futuristic worlds or utopian Edens? Often a flight of fancy brings unexpected pleasure to the creative mind, sparks a concept or thrills the nerves with a touch of terror. Most often such adventures of the mind are enjoyed and forgotten, but there are some individuals who rely on them—authors of children's fantasies, science fiction writers and illustrators, set and special effects designers, creators of theme parks and tellers of tales to name a few. For these people, and anyone else who enjoys fantasy, the pages of a sketchbook of imagination are a wonderful place to enliven and explore that which is conceived on the wings of a dream.

How does one begin the creation of fantasy? I start with real life. With some exaggeration and added features, a weathered old man can become a troll, an alligator can become a dragon, and an oversized insect with lots of slime can become a space monster. To invent stories to accompany the creatures, one may have to regress a bit and think with the mind of a child, for in childhood there exists the freedom to imagine anything!

On the preceding and following two pages I have dreamed up fairy folk to inhabit the forest surrounding my home. By setting them down in the pages of my journal, they not only bring pleasure to me, but I can share my imaginings with others. (My grandchildren love them!) Journal entries need not be elaborate. Let enjoyment and purpose influence the amount of time and effort you put forth. As Shakespeare put so well, "We are such stuff as dreams are made on." Only we can record the visions of our minds.

SOME DREAMS OR FANTASIES TO EXPLORE:

dragons and medieval lore ✻ elves, fairies, trolls ✻ folklore, myths and legends ✻ beasts and monsters ✻ phantoms and ghosts ✻ superheroes and heroines ✻ space creatures ✻ fictional worlds ✻ deep sea realms ✻ animals with human traits ✻ angels, religious figures ✻ prehistory, dinosaurs ✻ fantasy flora and fauna ✻ futuristic life, machines and vehicles ✻ robots ✻ animated objects ✻ fictional characters ✻ holiday symbolic characters ✻ nightly dream journal

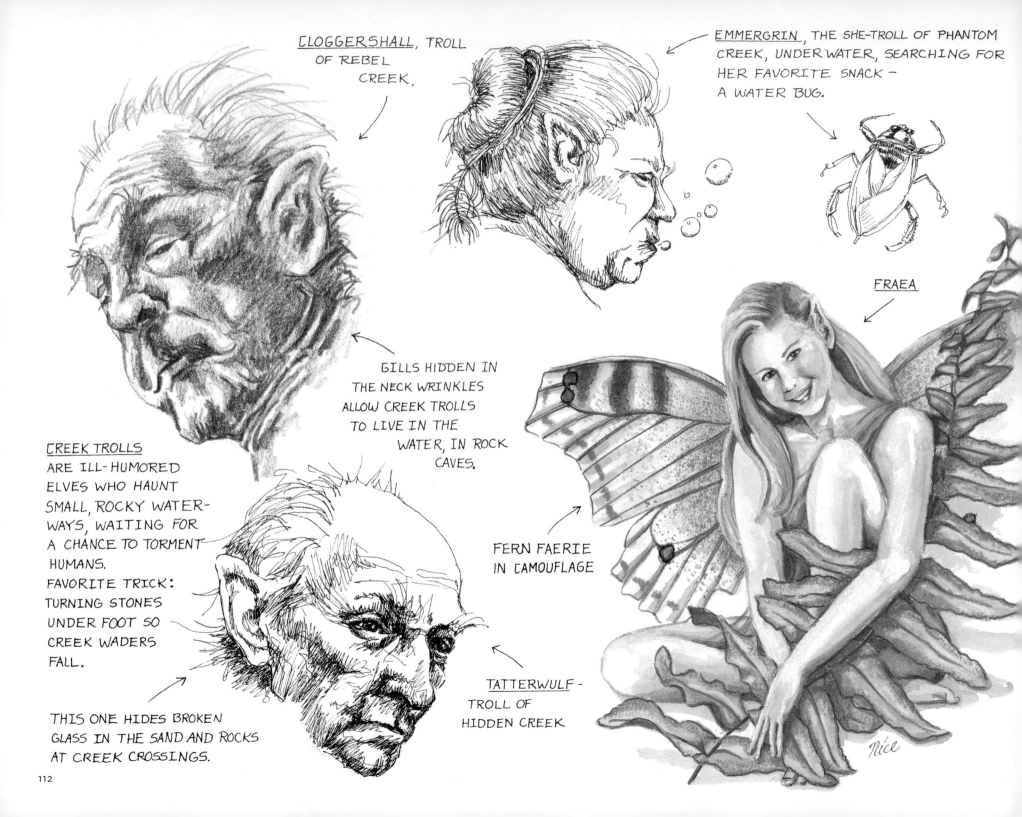

CLOGGERSHALL, TROLL OF REBEL CREEK.

EMMERGRIN, THE SHE-TROLL OF PHANTOM CREEK, UNDER WATER, SEARCHING FOR HER FAVORITE SNACK — A WATER BUG.

FRAEA

GILLS HIDDEN IN THE NECK WRINKLES ALLOW CREEK TROLLS TO LIVE IN THE WATER, IN ROCK CAVES.

CREEK TROLLS
ARE ILL-HUMORED ELVES WHO HAUNT SMALL, ROCKY WATER-WAYS, WAITING FOR A CHANCE TO TORMENT HUMANS.
FAVORITE TRICK: TURNING STONES UNDER FOOT SO CREEK WADERS FALL.

THIS ONE HIDES BROKEN GLASS IN THE SAND AND ROCKS AT CREEK CROSSINGS.

FERN FAERIE IN CAMOUFLAGE

TATTERWULF - TROLL OF HIDDEN CREEK

Nice

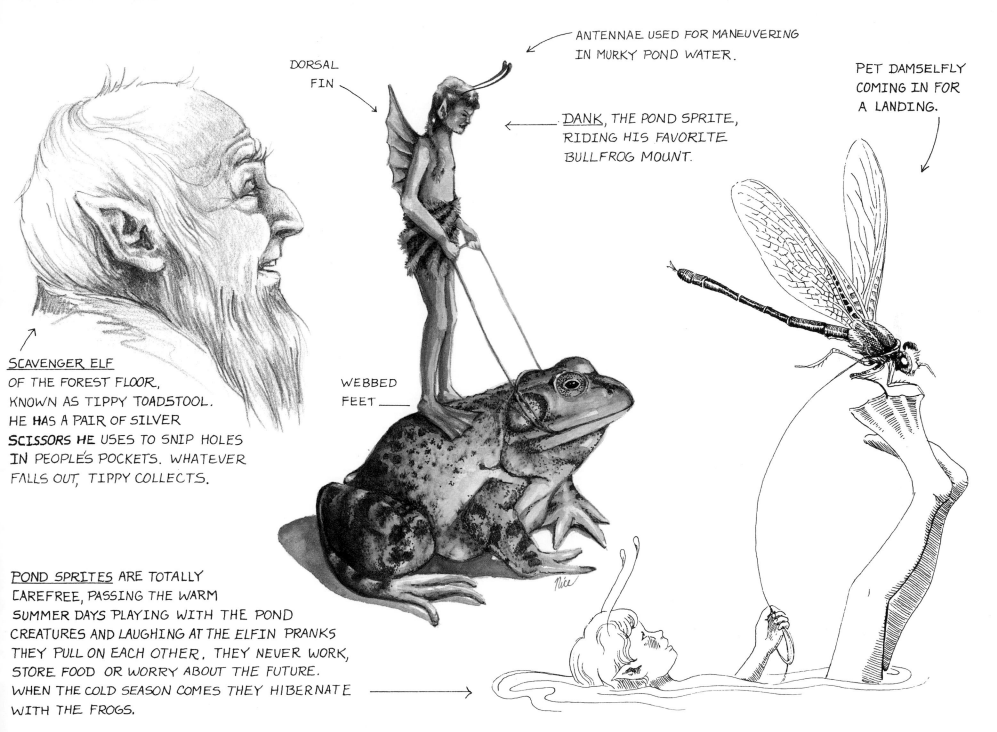

ANTENNAE USED FOR MANEUVERING IN MURKY POND WATER.

PET DAMSELFLY COMING IN FOR A LANDING.

DORSAL FIN

DANK, THE POND SPRITE, RIDING HIS FAVORITE BULLFROG MOUNT.

SCAVENGER ELF OF THE FOREST FLOOR, KNOWN AS TIPPY TOADSTOOL. HE HAS A PAIR OF SILVER SCISSORS HE USES TO SNIP HOLES IN PEOPLE'S POCKETS. WHATEVER FALLS OUT, TIPPY COLLECTS.

WEBBED FEET

POND SPRITES ARE TOTALLY CAREFREE, PASSING THE WARM SUMMER DAYS PLAYING WITH THE POND CREATURES AND LAUGHING AT THE ELFIN PRANKS THEY PULL ON EACH OTHER. THEY NEVER WORK, STORE FOOD OR WORRY ABOUT THE FUTURE. WHEN THE COLD SEASON COMES THEY HIBERNATE WITH THE FROGS.

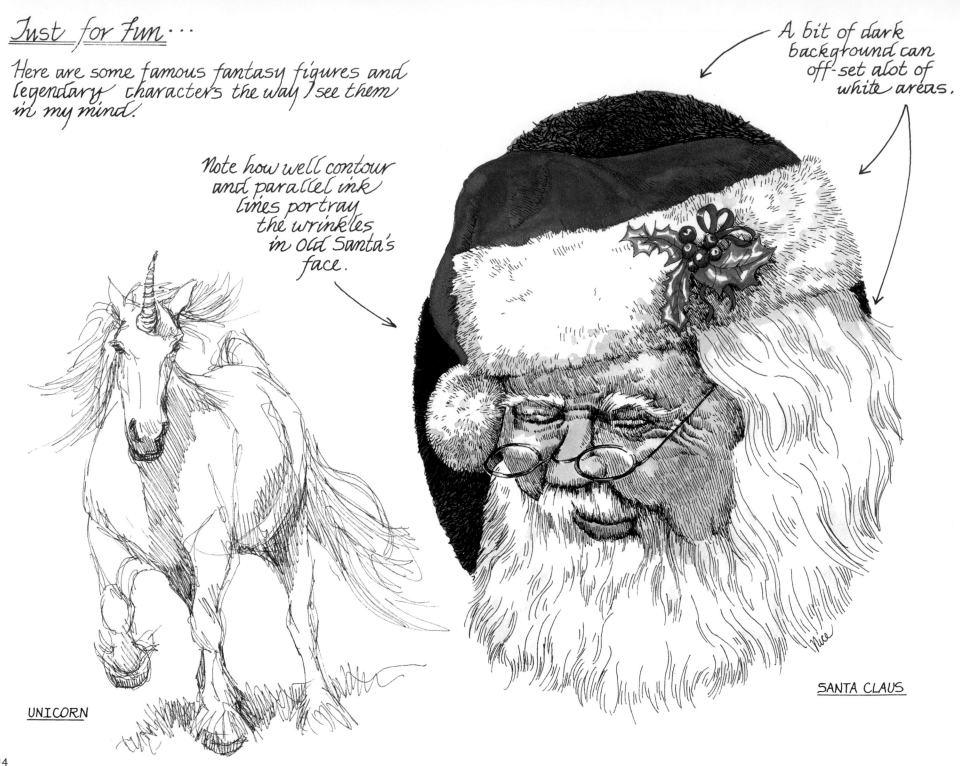

Just for Fun...

Here are some famous fantasy figures and legendary characters the way I see them in my mind.

A bit of dark background can off-set alot of white areas.

Note how well contour and parallel ink lines portray the wrinkles in old Santa's face.

UNICORN

SANTA CLAUS

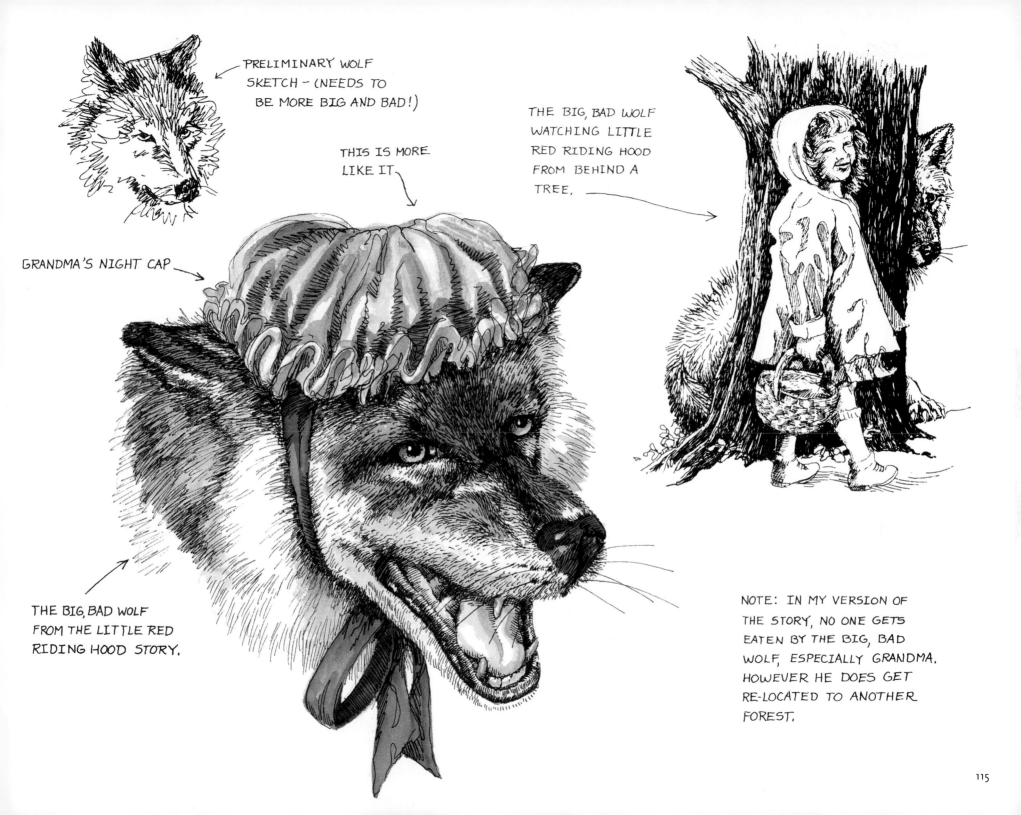

PRELIMINARY WOLF SKETCH – (NEEDS TO BE MORE BIG AND BAD!)

THIS IS MORE LIKE IT

THE BIG, BAD WOLF WATCHING LITTLE RED RIDING HOOD FROM BEHIND A TREE.

GRANDMA'S NIGHT CAP

THE BIG, BAD WOLF FROM THE LITTLE RED RIDING HOOD STORY.

NOTE: IN MY VERSION OF THE STORY, NO ONE GETS EATEN BY THE BIG, BAD WOLF, ESPECIALLY GRANDMA. HOWEVER HE DOES GET RE-LOCATED TO ANOTHER FOREST.

Heroes and Heroines

Tales of villians, heroes and heroines have always been popular with the young and young at heart. Here are the beginnings of a medieval fantasy, passed from my imagination to yours on the page of a journal.

ONCE UPON A TIME, IN A FAR AWAY LAND, LIVED ADAELE, PRINCESS OF THE REALM. FOULKLAWS, THE SORCEROR, CLAIMED HER AS HIS FUTURE BRIDE, AND SET A FEARSOME DRAGON AT HER SIDE TO GUARD HER DAY AND NIGHT FROM ALL OTHER SUITORS. ADAELE COULD BUT DREAM OF THE HERO TO SET HER FREE···

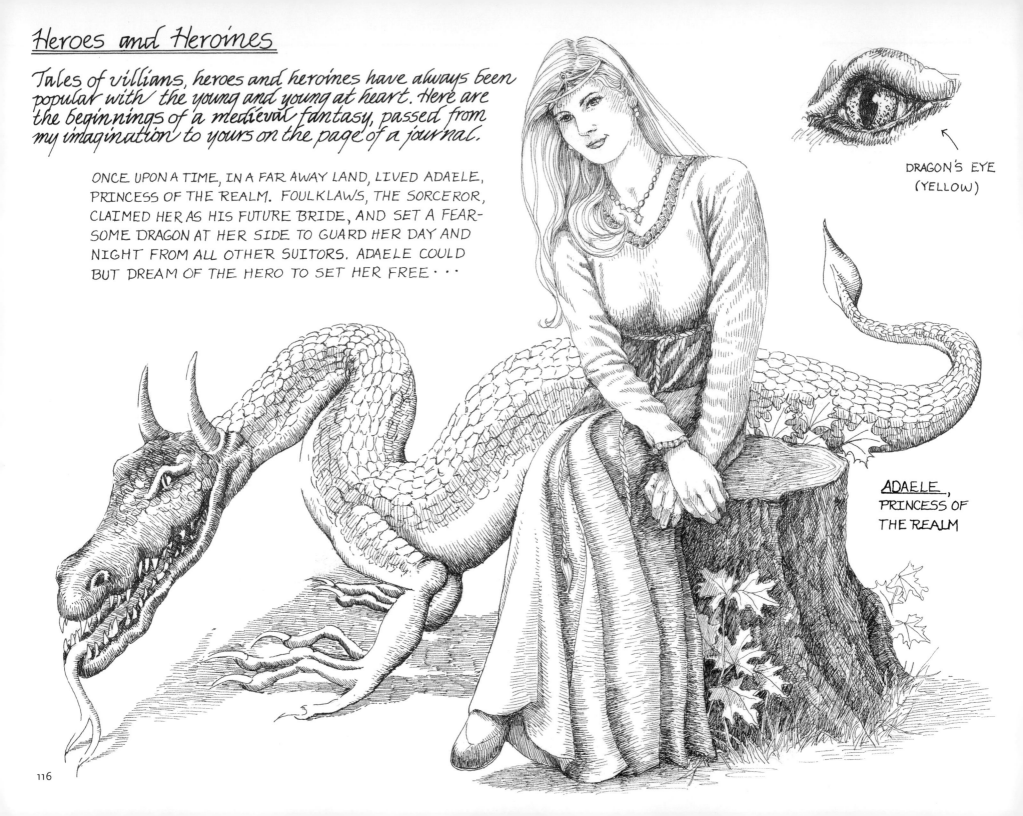

DRAGON'S EYE
(YELLOW)

ADAELE,
PRINCESS OF
THE REALM

Scary Stuff

I don't think much about monsters these days, but when I was a little kid, these creatures lived in my worst nightmares. For the science fiction writer, such notes and drawings could easily become the basis of a novel or movie.

Note how the dark, dirty colors and unfinished areas give the illustrations an aura of mystery and horror.

PROTRUDING EYES SEE EVERYTHING.

THE BOGIE-MAN - KNOWN TO HIDE IN CLOSETS AND UNDER THE BEDS OF CHILDREN.

WISPY, DEAD HAIR

VERY SKINNY

HUMAN SIZED HEAD.

SCENT SPORES, LEAVE A TRAIL FOR OTHERS OF ITS KIND TO FOLLOW. (SMELLS LIKE ROTTEN MEAT!)

SLIME TUBES, FILLED WITH DIGESTIVE JUICES.

BUG-LIKE SPACE CREATURE
(HANGS OUT IN DARK, CREEPY PLACES.)

THE HAND - WAITS UNDER THE OPEN-BACKED BASEMENT STAIRS TO GRAB YOUR ANKLES WHEN YOU DESCEND.

117

IN MY DAY

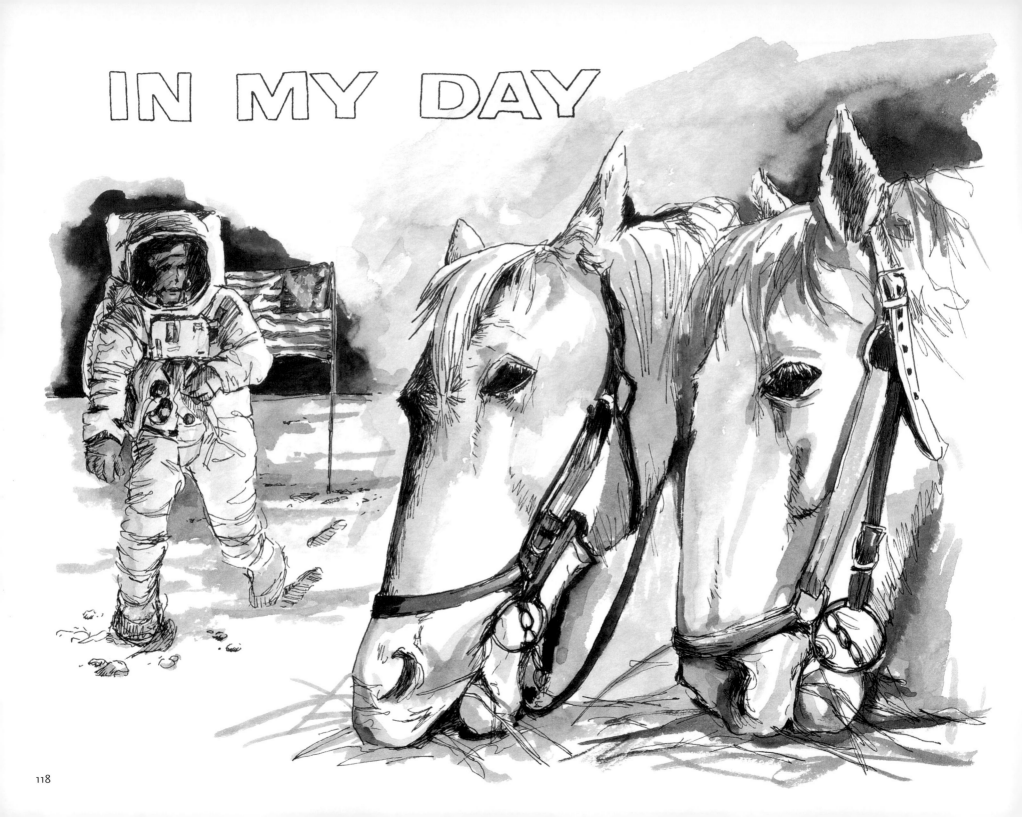

Chapter 11 — Keeping a Visual Diary

In my day, some farmers still used draft horses to work in their fields. In my day, man took his first steps on the moon. I saw these things and much more, and sketched them in my journal. Now that visual diary acts like a key to unlock a flood of personal memories.

Except for a couple of self-portraits and the lunar landing on the opposite page, all of the illustrations in my life journal were sketched on location, while the experiences were fresh. The touches, smells, sights and sounds of them were poignant, and whatever emotions they evoked were still influencing my mind. The draft horses illustrated on the adjoining page are a good example. I can't recall when they were sketched or even exactly where it was (my early journals were weak in written information), but I do vividly recall the scene: The team had been led into their dimly lit stall to eat their noon meal, their bodies still in harnesses. They shared a manger, their great heads close enough to touch. Their lips busily gathered hay and their ears flicked to gather sounds. I climbed right into the manger box beside them and began to sketch. I can still feel the warmth of their bodies and smell the pleasant aroma of hay mingled with "horse." I can still hear the rhythmic chomp of their teeth and the occasional stomp of a hoof and swish of a tail.

I feel a sense of peacefulness when I look at the hastily drawn sketch, and for a few moments I am there again. That's what a visual diary is all about. It should contain a sketch and enough written information to set the scene, even if it's only a few scribbled lines to capture the essence of the memory. It's the sketch that sets the visual diary apart from all the others and adds your unique personality to the record as nothing else can.

The sketch should relate to the experience of the moment, but does not necessarily have to be a drawing of the main subject. In other words, I may spend the day with friends at the beach, but sketch seashells instead of faces, sea and sand. When I see the seashell sketch, it reminds me of other things as well.

If it's not too difficult, record the bad experiences as well as the good. Both contribute to who you are. Spending the night in a homeless shelter (see page 125) was not very pleasant at the time, but it has become one of my favorite memories because of the insight I gained.

I have found it helpful to add written abridgments to the backs of some of my journal pages, briefly explaining what was happening during certain periods of my life. This information, which seemed obvious at the time, helped make the journal more understandable in later years. On the following pages, I have shared some of the entries of my own journals with you; the abridgments are marked with stars. I hope these pages amuse you and encourage you to begin or continue a visual diary of your own. Remember that each experience illustrated on the journal sheet is etched twice as deeply on the pages of your mind.

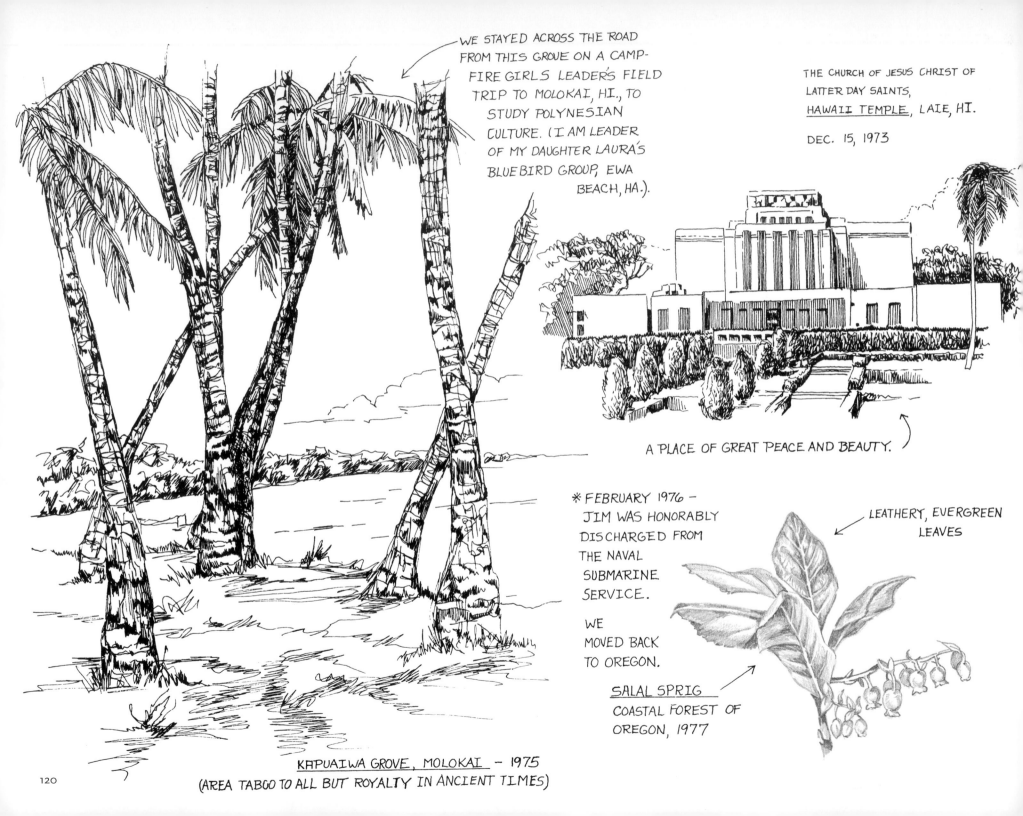

WE STAYED ACROSS THE ROAD FROM THIS GROVE ON A CAMP-FIRE GIRLS LEADER'S FIELD TRIP TO MOLOKAI, HI., TO STUDY POLYNESIAN CULTURE. (I AM LEADER OF MY DAUGHTER LAURA'S BLUEBIRD GROUP, EWA BEACH, HA.).

THE CHURCH OF JESUS CHRIST OF LATTER DAY SAINTS, HAWAII TEMPLE, LAIE, HI.

DEC. 15, 1973

A PLACE OF GREAT PEACE AND BEAUTY.

✳ FEBRUARY 1976 – JIM WAS HONORABLY DISCHARGED FROM THE NAVAL SUBMARINE SERVICE.

WE MOVED BACK TO OREGON.

SALAL SPRIG COASTAL FOREST OF OREGON, 1977

LEATHERY, EVERGREEN LEAVES

KAPUAIWA GROVE, MOLOKAI – 1975 (AREA TABOO TO ALL BUT ROYALTY IN ANCIENT TIMES)

✳ 1977–1982 WAS A TIME OF RETURNING
TO MY ROOTS AND RAISING MY
TWO YOUNG DAUGHTERS LAURA AND
CHANDRA. I INTRODUCED THEM
TO MANY OF MY FAVORITE
CHILDHOOD PLACES.

JULY 1980 –
<u>CROW ON A
SPRUCE BRANCH</u>,
CAPE LOOKOUT
BEACH, OR.

NICE

<u>NICE'S COTTAGE</u> – 1978
(FIRST HOME IN OREGON)

<u>OLD BURNED STUMP</u> – 1977

FOREST WHERE MY
GRANDPARENTS
ROSS LIVE.
OYSTER BAY,
WASH.

<u>CAMP CRAFT CABIN</u>, CAMP NAMANU, SANDY RIVER, OR. SUMMER 1983

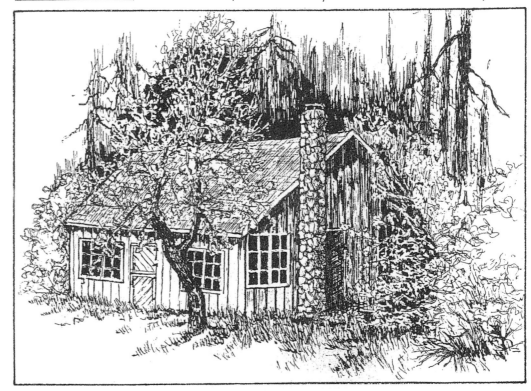

✳ -1981 - MY FIRST ART INSTRUCTION BOOK IS PUBLISHED.

-1983 - I BEGIN TRAVEL TEACHING AND DOING ART CONSULTANT WORK FOR KOH-I-NOOR RAPIDOGRAPH. IT IS A TIME OF PERSONAL GROWTH, EXCITEMENT, DISCOVERY AND ADVENTURES IN FAR AWAY PLACES.

AUG. 1982

<u>WILD MOUNTAIN GOATS</u>, SKETCHED AS THEY RESTED IN A SNOW PATCH TO COOL OFF.

FAMILY VACATION, HURRICANE RIDGE, WASH.

THEY WERE USED TO TOURISTS AND LET ME GET FAIRLY CLOSE.

<u>LILIES</u> ON MY BREAKFAST TABLE. DALY'S, WESTON HOTEL. OTTAWA, CANADA - 1983

(FIRST TEACHING TRIP OUT OF THE U.S.)

FEB. 1984
<u>FANEUIL HALL</u> AND NEARBY FLOWER STALLS BOSTON, MASS. - SALES MEETING.
(UNUSUALLY WARM, CLEAR, SUNNY DAY)

GINKGO LEAF - ONE OF SEVERAL I PLUCKED OFF THE WHITE HOUSE LAWN THROUGH THE IRON FENCE AND LATER SKETCHED.

NOV. 1984
WASHINGTON D.C.
(WORKED AT TRADE SHOW)

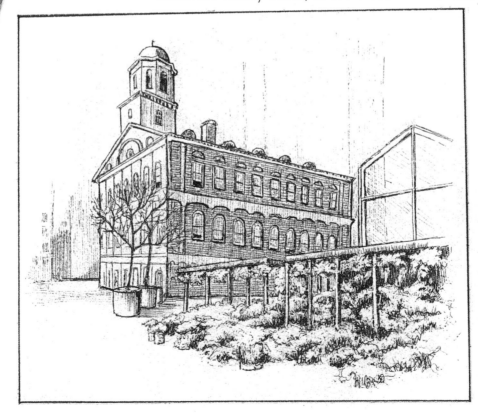

<u>SOUTHERN MAGNOLIA</u>
NEW ORLEANS, LA.
MAY 1984

TAUGHT ART CLASSES FOR KOH-I-NOOR AT THE NATIONAL ART MATERIAL TRADE ASSOC. HELD IN NEW ORLEANS.

I RODE THE CREOLE QUEEN RIVER BOAT DOWN THE MISSISSIPPI. IT WAS AN EVENING CRUISE - TOO DARK TO SKETCH!

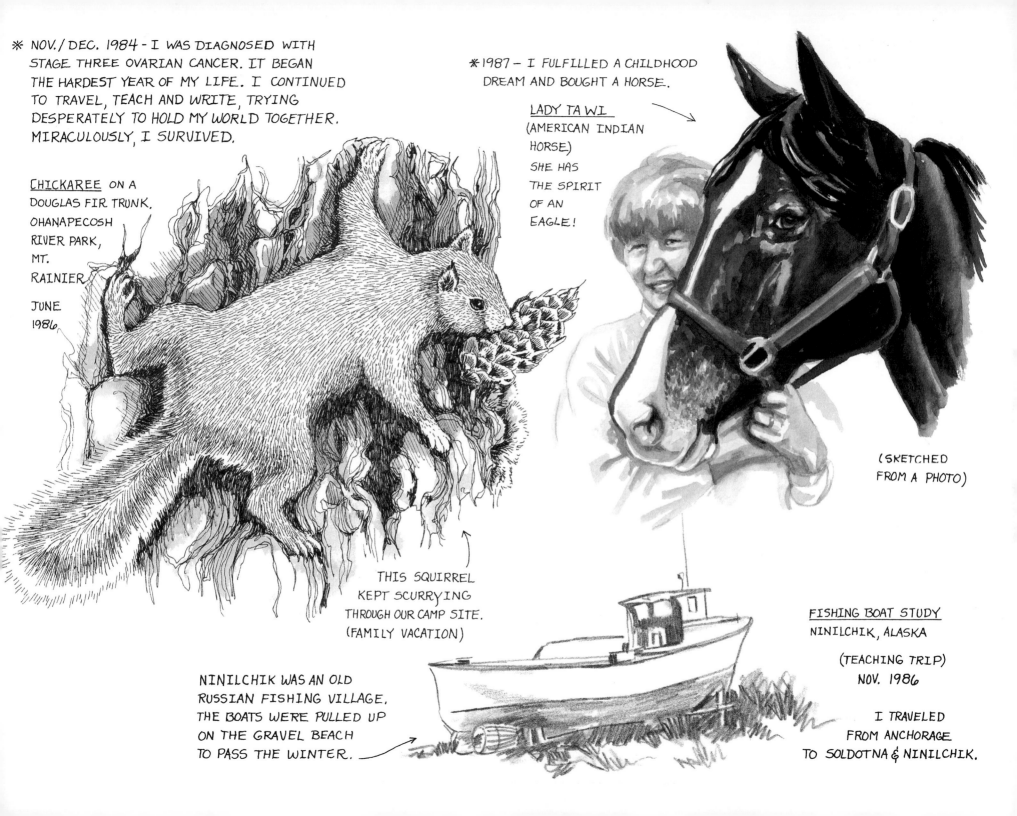

✳ NOV./DEC. 1984 - I WAS DIAGNOSED WITH STAGE THREE OVARIAN CANCER. IT BEGAN THE HARDEST YEAR OF MY LIFE. I CONTINUED TO TRAVEL, TEACH AND WRITE, TRYING DESPERATELY TO HOLD MY WORLD TOGETHER. MIRACULOUSLY, I SURVIVED.

CHICKAREE ON A DOUGLAS FIR TRUNK. OHANAPECOSH RIVER PARK, MT. RAINIER

JUNE 1986

✳1987 - I FULFILLED A CHILDHOOD DREAM AND BOUGHT A HORSE.

LADY TA WI (AMERICAN INDIAN HORSE) SHE HAS THE SPIRIT OF AN EAGLE!

(SKETCHED FROM A PHOTO)

THIS SQUIRREL KEPT SCURRYING THROUGH OUR CAMP SITE. (FAMILY VACATION)

FISHING BOAT STUDY NINILCHIK, ALASKA

(TEACHING TRIP) NOV. 1986

I TRAVELED FROM ANCHORAGE TO SOLDOTNA & NINILCHIK.

NINILCHIK WAS AN OLD RUSSIAN FISHING VILLAGE. THE BOATS WERE PULLED UP ON THE GRAVEL BEACH TO PASS THE WINTER.

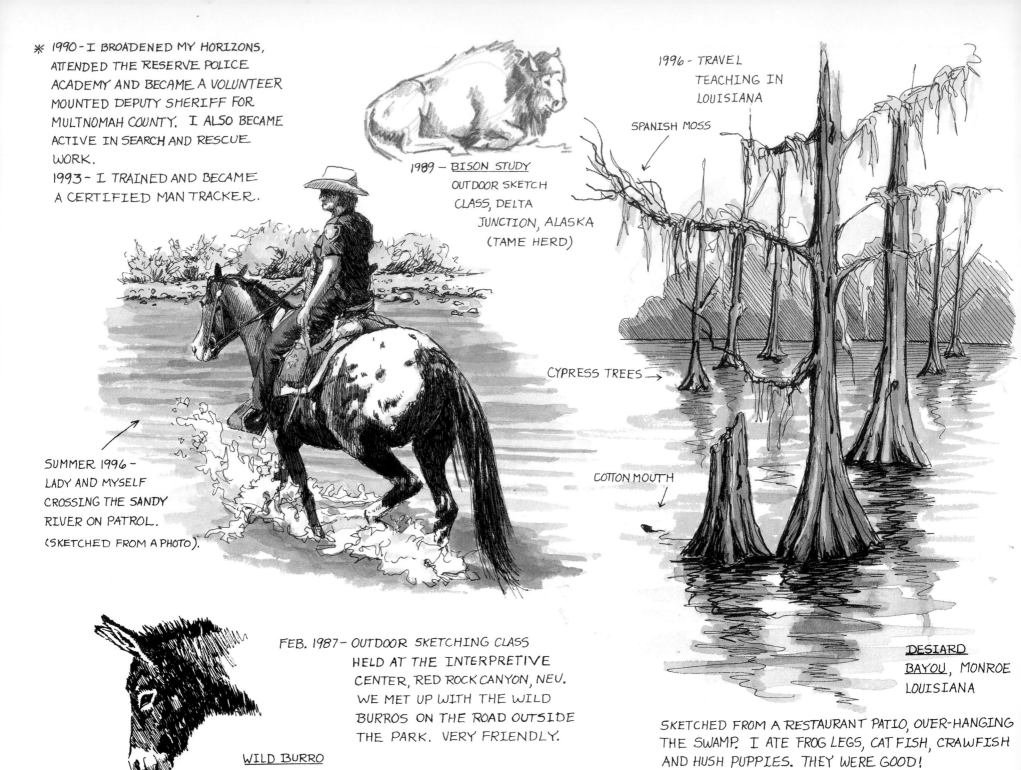

* 1990 - I BROADENED MY HORIZONS, ATTENDED THE RESERVE POLICE ACADEMY AND BECAME A VOLUNTEER MOUNTED DEPUTY SHERIFF FOR MULTNOMAH COUNTY. I ALSO BECAME ACTIVE IN SEARCH AND RESCUE WORK.
1993 - I TRAINED AND BECAME A CERTIFIED MAN TRACKER.

SUMMER 1996 - LADY AND MYSELF CROSSING THE SANDY RIVER ON PATROL. (SKETCHED FROM A PHOTO).

WILD BURRO

FEB. 1987 - OUTDOOR SKETCHING CLASS HELD AT THE INTERPRETIVE CENTER, RED ROCK CANYON, NEV. WE MET UP WITH THE WILD BURROS ON THE ROAD OUTSIDE THE PARK. VERY FRIENDLY.

1989 - BISON STUDY
OUTDOOR SKETCH CLASS, DELTA JUNCTION, ALASKA (TAME HERD)

1996 - TRAVEL TEACHING IN LOUISIANA

SPANISH MOSS

CYPRESS TREES →

COTTON MOUTH

DESIARD BAYOU, MONROE LOUISIANA

SKETCHED FROM A RESTAURANT PATIO, OVER-HANGING THE SWAMP. I ATE FROG LEGS, CAT FISH, CRAWFISH AND HUSH PUPPIES. THEY WERE GOOD!

HOMELESS
SHELTER

MAY 10, 1996 -
FLYING HOME FROM A TORONTO
BUSINESS TRIP, I AM STRANDED
IN CHICAGO DUE TO A BAD STORM.
ALL FLIGHTS ARE CANCELED. ALL
HOTELS ARE BOOKED. I AM DIRECTED
TO THE AIRPORT HOMELESS
SHELTER AND GIVEN A COT FOR
THE NIGHT. I AM HUMBLED BY
THE EXPERIENCE AND GRATEFUL
FOR A SAFE PLACE TO SLEEP.

3:30 A.M. - I AM AWAKE, RESTLESS
AND DECIDE TO SKETCH. THERE
IS AN OLD WOMAN WHO SITS
NEARBY CLUTCHING A COFFEE
MUG. SHE STARES ABOUT WITH
A LOST EXPRESSION. BESIDE
ME SLEEPS A MAN AND HIS
LITTLE BOY. THEIR SHOES ARE
PLACED CAREFULLY UNDER
THE COT. TRAVELERS OR HOME-
LESS PEOPLE? WE ARE ALL THE
SAME TONIGHT.

2000 New Millennium

SAN FRANCISCO (I'M TEACHING CLASSES AT ART MATERIALS TRADE SHOW, FORT MASON).

NOV. 1998 -
VIEW FROM THE
MARINA, SAN
FRANCISCO BAY.
IT'S EARLY
MORNING,
FOGGY AND
THE WATER IS
STILL. GULLS
SOAR OVER
HEAD. ——→

THE YEAR 2000 ARRIVES! IT'S THE LAST
DAY OF THE 20TH CENTURY. I'M PREPARED
FOR Y2K, TERRORISTS OR WHAT EVER.
I WATCH MIDNIGHT ARRIVE ACROSS THE
WORLD ON THE T.V. THERE IS MUCH
JOY, EXCITEMENT AND CELEBRATION.
FIREWORKS DISPLAYS LIGHT THE SKY,
NO DISASTERS, ONLY PEACE AND
UNITY. I AM THRILLED BY IT ALL.

125

Index

GET THE BEST OF FINE ART INSTRUCTION FROM NORTH LIGHT BOOKS!

Charles Reid is one of watercolor's best-loved teachers, a master painter whose signature style captures bright floral still-lifes with a loose spontaneity that adds immeasurably to the whole composition. In this book, Reid provides the instruction and advice you need to paint fruits, vegetables and flowers that glow.

Special "assignments" and step-by-step exercises help you master techniques for wild daffodils, roses, mums, sunflowers, lilacs, tomatoes, avocados, oranges, strawberries and more!

1-58180-027-4, hardcover, 144 pages

Frank LaLumia takes you into his confidence and shows you how to capture nature's three-dimensional glory in oil and watercolor at any time and place.

You'll learn the basics of rendering natural light and color, how different paints can affect your plans for working in the field, and how fluency in the language of painting allows you to capture those extraordinary, magical happenings in the world beyond your window.

0-89134-974-X, hardcover, 128 pages

Learn how to create nature paintings of extraordinary intimacy and mystery-visions of a secret world you never see.

Here you'll find step-by-step guidelines that work for whatever medium you use. Whether painting scales, feathers, sand or fog, you'll learn to render the trickiest of details with skill and style. A full-size demo, combining animals with their environment, focuses all of these lessons into one dynamic painting.

1-58180-050-9, hardcover, 144 pages

Using a few brushes, some rice paper and a small number of inks and paints, you can explore new realms of watercolor art. Lian Quan Zhen provides step-by-step instructions that enable you to apply every brushstroke with strength and confidence.

And you'll find inspiration in Zhen's own works—created with the best techniques from East and West. He'll show you that the beauty of fine art crosses every border and that your artistic journey has no limits.

1-58180-000-2, hardcover, 144 pages

From à la poupée to Zinc White, this book is packed with more than one thousand art definitions—including hundreds of photographs, paintings, mini-demos, black & white diagrams and drawings for comprehensive explanation.

You'll also find sidebars about specific entries and charts for a wealth of inter-related information in one convenient listing.

1-58180-023-1, paperback, 488 pages

No matter how little free time you have available for painting, this book gives you the confidence and skills to make the most of every second. Learn how to create simple finished paintings within sixty minutes, then attack more complex images by breaking them down into a series of "bite-sized" one-hour sessions.

12 step-by-step demos make learning easy and fun. You'll find that whatever time you have to paint is really all the time you need!

1-58180-035-5, paperback, 128 pages